Everything
You Know
About Art
Is Wrong

To Mum, Dad and Uncle Chris

First published in the United Kingdom in 2017 by
Batsford
43 Great Ormond Street
London WC1N 3HZ
An imprint of Pavilion Books Company Ltd

ISBN: 9781849944298

A CIP catalogue record for this book is available from
the British Library.

25 24 23 22 21 20 19 18 17
10 9 8 7 6 5 4 3 2 1

Reproduction by Mission, Hong Kong
Printed by 1010 Printing International Ltd, China

This book can be ordered direct from the publisher
at the website www.pavilionbooks.com, or try your
local bookshop.

Everything You Know About Art Is Wrong

Matt Brown

BATSFORD

Contents

Art's Daftest Conspiracy Theories 130

Introduction

This is a book about the joys and opportunities of being wrong. Specifically, being wrong about art in any form. One of my earliest memories involves being wrong about art.

As a young child, I watched an art show in which the host created beautiful images with pastels. This was exciting. I wanted to have a go. If I could get my hands on some pastels, I could impress my chums, who were still struggling along with felt tips, wax crayons and the wishy-washy paints of the infant classroom. Pastels looked sophisticated.

Clutching my pocket money, I marched round to the supermarket, bought my supplies and headed into school. But something went wrong. My pack contained a range of coloured pastels, but none of them would leave much of a mark on paper. Worse, my sheet became torn and sugar coated as I dragged the pastels across its surface. Turns out that fruit pastilles are not the same thing as pastel crayons.

It was an embarrassing mistake, but one I never forgot. That's the thing about getting something wrong – it sticks in the memory. And that is where the inspiration for these books comes from. Presented in these pages are dozens of ideas about art that many of us take for granted which, with some probing, turn out to be wrong, or only partially correct.

Despite the title, my chief ambition here is not to poke holes in people's knowledge nor to ridicule common ignorance. Rather, I'm hoping to tell the story of art through a different filter. If it's true that we learn best from our mistakes, then it seems to me that a focus on those mistakes is the most efficient way to get under the skin of a subject.

One of the pitfalls of describing art is that, to use an old cliché, a picture is worth a thousand words. A writer will often spend several paragraphs minutely describing the appearance of a painting – partly because the book's illustration budget didn't allow for reproductions. Neither does mine. But nor, in the 21st century, does it need to. Most of us now have a smartphone or tablet within reach at all times – you might even be reading on one. If I mention an unfamiliar work of art in the text, by all means look it up on an image search. Pan around; zoom in. Get a feel for the work before returning to the book. It's not cheating. Quite the opposite. You can often study paintings at far higher resolution than any print reproduction would allow, and I'd rather fill these pages with intriguing stories than labour away at descriptions.

Another peril before me is the nebulous nature of the topic. The question 'What is art?' has an infinity of answers, and my personal take on the subject may well be very different from yours. I've chosen to focus on the so-called fine arts of painting and sculpture, with elements of drawing, photography and architecture thrown in for good measure. I'm aware that the topics also have a strong bias towards Western art. This is a necessary and inevitable limitation of a book dealing with misconceptions among a mostly Western audience.

So, sit back, prepare to abandon your old beliefs and prejudices about art, open a packet of fruit pastilles, and let the nitpicking begin.

Before we get down to specifics, let's spend a chapter looking at the art world itself. What is art? How is it created? How is it displayed? And how true are the stereotypes about artists?

The World of Art

All artists are tortured geniuses who live Bohemian but impoverished lifestyles

We all have a picture in our heads of the stereotypical artist: a tatterdemalion maestro, frantically working at his canvas. A loner, locked away in his garret for hours, with only a bottle of absinthe, a pile of final demands and the demons in his head for company. The artist must suffer for his art.

Like all stereotypes, this picture contains a kernel of truth. Many artists have worked under impoverished conditions. Some of the biggest names in art suffered from mental-health issues. Plenty of artists have risked their well-being and finances in pursuit of creative perfection.

Is that right, though? Is it always like that? Well, of course not. Artists come in all shapes, flavours and income brackets, just like people of any other profession. Yes, there have been several notable artists with troubled minds – van Gogh (1853–90) and Goya (1746–1828) to name but two – but one might also list dozens of musicians, authors and composers who have struggled with mental-health difficulties. The list need not be limited to traditional creative types, either. Statesmen such as Caligula, Lincoln and Churchill, and the entrepreneur Howard Hughes, are all high-profile examples. Artists have no monopoly on a tortured mind.

What about the notion that mental instability can drive creativity? After all, van Gogh painted some of his greatest works, including *Starry Night*, while living in a mental asylum. The old platitude that 'there's a fine line between madness and genius' might seem reasonable. After all, creative people are, by definition, those who are able to use their minds in ways that others can't. Indeed, scientific studies, published in respectable journals, have shown links between creativity and mental illness. In one study, artists and other creative professionals were found to be 25 per cent more likely to carry genes associated with bipolar disorder and schizophrenia. To bend a crass cliché, you don't have to be crazy to work as an artist, but it helps.

Or does it? Correlation does not imply causation. Artists might be more likely to suffer from mental-health problems, but that does not mean their ailments drive their creative powers. One could think of alternative theories for the genetic connection. It could be that those with mental illnesses are drawn towards the arts more than those without, as an outlet for

emotions. It's not that their difficulties make them more creative, but that they're more likely to pick up a paintbrush in the first place. Other credible research has shown that creativity is enhanced by a positive mood, and inhibited by a negative mood, seemingly contrary to the expectations of the 'tortured genius'. Whatever the case, the connection between creativity and mental illness remains debatable.

The myth of the starving artist, meanwhile, has many origins, both real and fictional. One oft-quoted source is the 19th-century novel *Scènes de la vie de bohème* by Henri Murger (1822–61). This popular book depicted a set of indigent artists living in the Bohemian quarter of Paris. This lifestyle – eschewing the pursuit of wealth for the purity of art – became the romantic ideal of the struggling artist. The great creators must cast aside everyday distractions like eating, personal hygiene and earning a wage, and put all their powers into their work.

The passionate struggle may be seen in some artists, but it's also true of anyone with a driven mind. How many business owners put in 15-hour days to get their start-up off the ground? I've known accountants burn the midnight oil in order to complete tax returns. The notion of going without food, rest or sleep to focus on just one thing will sound very familiar to anybody with a small child. Artists are not the only ones to toil.

The idea that artists must spend their lives as paupers is also flawed. History is littered with wealthy artists, as well as poor ones. Michelangelo (1475–1564), despite constantly complaining about his unpaid commissions, amassed a personal fortune estimated at £30 million in today's money. His contemporaries, such as Leonardo (1452–1519), Raphael (1483–1520) and Titian (1490–1576), were not quite so flush, but all lived in style, with grand houses and fine clothes.

Anthony van Dyck (1599–1641) amassed his great wealth from the English Crown, and lived in a suite of rooms at the royal palace of Eltham near London. His tomb in St Paul's Cathedral was destroyed during the Great Fire of 1666, but recorded a life lived magnificently, 'more like a prince than a painter'. Society portrait specialists, such as Joshua Reynolds (1723–92) and John Singer Sargent (1856–1925), were able to live well-to-do lifestyles,

socializing with their wealthy patrons. Paul Cézanne (1839–1906) inherited a fortune from his banker father, and never struggled to pay a bill. When Picasso (1881–1973) died, his estate was audited at between $100 million and $250 million. In today's money, he might have been a billionaire. Many further examples can be plucked from the history books, perhaps enough to cancel out such painter-paupers as Rembrandt (1606–69), Gauguin (1848–1903) and Toulouse-Lautrec (1864–1901).

The difference between rich and poor is even greater in today's art world. At the top end, Damien Hirst (born 1965) presides over a fortune estimated at $1 billion, making him the wealthiest artist of all time. This is an artist whose works include a platinum skull encrusted in diamonds. He's also the only artist to have a work of art on Mars*. All a far cry from the struggling romantic labouring away in a bedsit.

Hirst is not alone. Half a dozen living artists – among them Jeff Koons (born 1955) and Takashi Murakami (born 1962) – command bank accounts with nine figures. On the other hand, the world has no shortage of art students struggling to make ends meet. But is that because they're artists, or because they're students?

* FOOTNOTE One of the artist's spot paintings was carried by the British Beagle 2 probe, launched in 2003, to be used as a colour calibration chart for the robot's sensors. Unfortunately, contact was lost with Beagle 2 before it could send back any data. We now know that Beagle made it safely to the surface but was unable to contact Earth. Hirst's spot painting is almost certainly intact, and therefore the only work of art on Mars.

Art is a young person's game

The windswept Barnoon Cemetery in St Ives ranks among the most photographed in England. Its belichened gravestones have featured in countless films and TV programmes thanks to their outlook over the azure Cornish seas. Among the tumble of weather-beaten headstones lies something unique – a lighthouse. This is not a beacon to warn people away, but a pictorial lighthouse, marked on a grave to draw in the curious. This monument in glazed, coloured stone is the most impressive in the cemetery. Yet it marks the final resting place of a working-class fisherman.

Alfred Wallis (1855–1942) was in many ways a typical Cornish labourer. From a young age, he would venture out to sea on fishing boats and merchant vessels, sailing as far as Newfoundland. In later years, Wallis turned to scrap dealing, and the sale of marine equipment. It was a hard life, but not an unusual one. Then, the loss of his wife in 1922 changed everything. The ageing fisherman took up painting 'for company', and filled his house with depictions of the sea.

It was a case of right place, right time. A few years later, the noted artists Ben Nicholson (1894–1982) and Kit Wood (1901–30) arrived in St Ives, hoping to establish an artists' colony. They were enchanted by the paintings of this humble fisherman, now well into his 70s. Although in many ways naive, Wallis's seascapes possessed a clarity borne of deep familiarity. As Nicholson put it, the paintings showed 'something that has grown out of the Cornish seas and earth and which will endure'.

Wallis became a big influence on the artists, and helped cement St Ives' reputation for art, still intact today. Although he may never have picked

up a paintbrush until he was almost 70, Wallis went on to become a celebrated artist whose work is still much loved. Some of his paintings can be viewed in the St Ives branch of the Tate gallery, a few hundred metres from his distinctive grave.

Wallis bucks the notion – common across the arts – that creativity is a young person's game. Great art needs great energy and passion, and the courage to rebel against the establishment. Life saps this vigour. Our drive and ingenuity diminish as our hair greys. Or so the prejudice goes. We tend to lionize those painters who suffered for their art and died young: think van Gogh (aged 37), Kahlo (aged 47), Caravaggio (aged 38), Modigliani (aged 35), Pollock (aged 44) or Basquiat (aged 27). But a great deal of the best work comes with maturity. There is no shortage of examples of famous artists working well beyond the usual age of retirement or, in cases like Wallis, only beginning an artistic career at this age.

Another notable latecomer is Alma Thomas (1891–1978), an Expressionist painter from Washington D.C. Unlike Wallis, Thomas had always had a fizz of creativity about her; she was the first student to be awarded a Batchelor's degree in Fine Art from Howard University, and served for many years as an art teacher. But she only set up as a professional painter upon retiring from education in 1960, by which time she was 71. Many of her best works – colourful abstract designs – were made in her 80s. One of her paintings was chosen for the White House during the Obama administration.

Self-taught artist Henri Rousseau (1844–1910) didn't leave it quite so late. The French customs officer was merely in his 40s when he made his artistic debut. Though naive in style, his paintings now hang in the world's top art galleries. The Abstract Expressionist Janet Sobel (1894–1968) was another who only took up art in her middle years. Despite the late start, she contributed to the emergence of drip painting, more commonly associated with Jackson Pollock.

Surely the most extreme example is the Aboriginal Australian artist Loongkoonan (born 1910). She first decided to paint at the age of 95 and, at the time of writing, is still going strong at 105 years old. Her works draw on a century of memories, depicting indigenous motifs with colourful

painted dots. She has achieved fame in her native country and has recently exhibited in Washington D.C., although the journey was too long to allow her to attend in person.

As well as late-found talent, the history of art is littered with longevity among established artists. Many of the Old Masters created their best work in later life. The Venetian master Titian (c.1490–1576) lived to an indeterminate age between 80 and 100, though most likely around 90. Creative until the very end, his final painting, *Pietà*, was (almost) completed in the year of his death, and was possibly intended to hang in his tomb. Not everyone thought his staunch refusal to retire was a good idea. The contemporary art historian Giorgio Vasari (1511–74) wrote that 'It would have been better for him in those last years to have painted only as a hobby so as not to diminish the reputation gained in his best years.' This final phase in Titian's life is now much better appreciated. His looser use of the brush, perhaps the effect of increasing frailty, gives his late works a certain freedom, which edges towards Impressionism. Other octogenarian Old Masters include sculptor Gian Lorenzo Bernini (died 1680, aged 81), portraitist Frans Hals (died 1666, aged 84), and, of course, Michelangelo, who kept chipping away at marble until he finally keeled over in 1564, aged 88.

Indeed, few artists ever do retire, unless forced into it by infirmity. Once the creative urge is unleashed and nurtured, it becomes part of the artist's identity that cannot be quashed. Many artists not only continue to make art into old age, they continue to make *great* art. The hugely influential artist Louise Bourgeois (1911–2010), for example, began her career in the 1930s and was busy right up to her death at almost 100. Her most famous pieces, giant spider sculptures that have been exhibited all over the world, were created in the 1990s while Bourgeois was in her 80s. Henri Matisse (1869–1954) saved his most original work for his final decade. Bedridden with illness, he turned to the art of collage, creating his famous cut-outs with the help of assistants.

The most noted example is Pablo Picasso (1881–1973), who lived to the ripe old age of 91, producing art that was fresh and adventurous (some would say pornographic) right to the end. His late works sell for multi-millions at auction. The most expensive of all, *Les Femmes d'Alger*, was painted in 1955

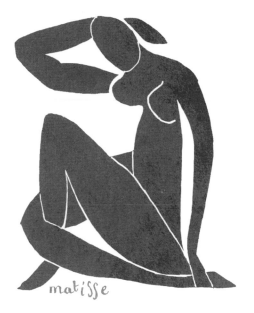

matisse

when Picasso was in his mid-70s. It sold for $179.4 million in 2015, and remains one of the most valuable artworks in the world.

And so the list continues. Willem de Kooning (1904–1997) lived to 92, making paintings into his 80s. David Hockney (born 1937) is busier than ever as he too enters his 80s. And then there is the exceptional case of Carmen Herrera (born 1915). The Cuban-American artist has, for decades, produced bold, geometric forms of Minimalist art, now acknowledged as among the most groundbreaking in the genre. Herrera, though, painted in relative obscurity until 2004, when her work was included in an exhibition of female geometric painters after a more famous artist dropped out. She sold her first painting that year, aged 89. As of 2017, Herrera was still creating bold new works at the age of 101 with the help of an assistant, and enjoying a sell-out retrospective at Manhattan's Whitney Museum.

It's simply not true that art is a young person's game. Some of the greatest creative works in history came from the imaginations of people in their 60s, 70s and 80s.

Art is useless, a waste of money

It's easy to dismiss the art world, and many people do. What is the point of all this useless beauty? How does a portrait of a forgotten Venetian merchant enrich my life? Why should we spend so much public money on subsidizing art, when the funds might instead be diverted to hospital beds, or teacher training, or improving the transport network? What *use* is art? These are all good questions. We better have some good answers.

First, why do things need to have a use to be worthwhile? A football team has no use. Not really. Those eleven men or women entertain their fans, but they don't train up nurses or lay new rail tracks or do anything else that might reasonably be described as useful. Soap operas have no use, but it doesn't stop people tuning in by the million. To quote an old cliché, what use is a newborn baby? Isn't it enough that art brings pleasure to, and enriches the lives of, those who seek it out?

And, anyway, art does have its uses – plenty of them. We can learn so much from studying paintings and sculpture. The dedicated art-goer will, over time, hone the skills of observation, and acquire different ways of looking at the world. Historical paintings can spark an interest in past events, and give us at least some sense of what it might have been like to witness them. Likewise, paintings on religious or mythological themes reinforce our understanding of those worldviews.

Art through history had many purposes other than to look pretty, and that is still true today. Next time somebody blithely declares that art is 'useless', a 'waste of time' or a 'waste of money', consider drawing from the following list that shows just how useful art can be.

As an aid to learning Art can teach us much about the history and cultures of the world, and it has often been employed for pedagogical purposes. Christian religious paintings and stained-glass windows, for example, were partly intended to remind an illiterate audience about the lessons of the Bible. Similarly, the story of the Buddha has been told and retold through countless sculptures and reliefs. Historical paintings bring to life naval engagements, coronations or calamities from the centuries when photography or video did not exist to record such occasions for posterity. In addition, many of the great names of history would be faceless to us without the arts of portraiture and sculpture. Would Elizabeth I or Napoleon resonate in our imaginations to the same degree if we did not know what they looked like?

For political propaganda History brims over with examples of art and imagery bent to political ends. Army recruitment posters featuring Uncle Sam or Lord Kitchener readily spring to mind. A more recent example is the HOPE image of Barack Obama, created by street artist Shepard Fairey (born 1970); and subsequently the spin-off NOPE posters of anti-Trump protesters. Art as propaganda is as old as civilization. The Assyrians and Babylonians, for example, recorded their victories in mighty friezes – a way of aggrandizing the king or military leader and cementing his reputation among the populace.

For devotion and meditation Today's action figures – often depicting muscular characters with superhero powers – would be very familiar to the Romans. Every Roman home had its sculpted figurines, known as *Lares*, which were used as devotional objects. Just like today's action figures, these small statues came in innumerable forms, and represented powerful individuals – usually gods or ancestral spirits rather than Ninja Turtles or Jedi Knights. The figures were placed in household shrines, often painted with additional *Lares*. Similar sculptural and painted forms, created for meditative purpose, can be found in many other cultures around the world. Buddhists use complex symbolic and geometric patterns known as mandalas to help with this. The act of creation can itself be meditative. The amateur watercolourist takes his or her easel outdoors as much to find inner peace as to create a work of art.

To amuse There's a whole world of cartoon, animation and humorous greeting cards out there designed to make us chuckle, but artists have been raising a smirk for millennia. Satirical drawings are known from the ancient world. An Egyptian stone dating back to more than 1,000 years BCE, for example, shows a cat serving food to a seated mouse. It is the original lolcat. Medieval manuscripts often contain ribald depictions of bodily functions, surely drawn with humorous intention. William Hogarth (1697–1764) made his name by painting satirical views of 18th-century society, as did numerous cartoonists in the emerging press. The Surrealists gave a new lease of life to humour in art, from Salvador Dalí's (1904–89) lobster telephone to René Magritte's (1898–1967) *La Clairvoyance*, which shows a man painting a bird, while looking at an egg. The rise of street art and the spread of visual media through the Internet have only increased our appetite for humorous art.

To assist in the afterlife The ancient Egyptians put a lot of effort into death. No self-respecting pharaoh would go to his tomb without a heap of useful objects for use on the other side. The walls of his burial chamber would be painted with similar goods and comestibles, as well as the images of servants.

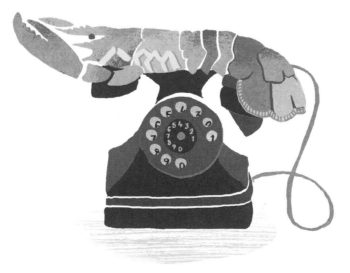

As memorial Art can also help us remember the dead. The best artists and architects are often called upon to create our war memorials, or commemorate those who died in other tragedies. Most big cities also contain statues and busts recalling the great scientists, reformers, writers, musicians and fellow artists who made a lasting contribution to society. Our collective memory for the heroes of the past would be impoverished without such works of art.

For therapy Many people find that making art is a relaxing, calming experience. Art therapists take this one stage further, by using art to help those with physical, mental or emotional problems. Painting or drawing, for example, can help a person to express deep anxieties, which can then be talked through with the therapist. It seems to work for some people but, to be fair, its general effectiveness is difficult to pin down.

As an investment Perhaps the best argument against anyone who thinks art is a waste of money is to respond in financial terms. Art collectors don't all acquire masterpieces simply to have something pretty to put in the corner of the study. Like fine wines and first-edition books, art can also serve as a lucrative investment. Stocks and shares fluctuate in value at the whims of the market, while physical objects can offer a more stable option. A Rembrandt is still a Rembrandt and does not get less desirable as the economy plunges.

A well-chosen piece of art can not only bring a good return on investment when it's sold on, but also gives the buyer pleasure and social cachet in the meantime – something you just don't get from a wad of share certificates. Contemporary art can yield a particularly good profit if you can catch a superstar artist while they're still on the way up.

All that said, art for investment is not without its own considerable risks and complications. Transactions are loosely regulated compared with those on traditional financial markets. Serious investment often requires expert advice, which doesn't come cheap. And there's always the risk you might pick up a forgery. Still, in a 2016 report by Deloitte, 72 per cent of art collectors reported that their purchases were not just about passion, but also had a view to investment. When you look at the size of the

market – something like $60–70 billion is spent on art per year – financial investment is clearly a leading 'use' of art.

To show off Nothing says 'I'm rich and discerning' as much as having a few famous artists on your walls. The notion goes back at least to the Renaissance, when wealthy merchants and rulers would commission big names to decorate their palazzi and villas. Yes, it was a pleasing bit of home improvement, but it was mostly to show off their wealth and taste to visitors. The grandest example of all is the Palace of Versailles near Paris. Louis XIV and his successors turned it from a mere hunting lodge into a vast show house of decorative and fine arts. Needless to say, the accumulation and display of such baubles is still a popular hobby among the world's elite.

For diplomacy World leaders and high-ranking politicians customarily swap gifts whenever they meet, as a way of cementing good will between nations. Works of art are a popular choice. Britain's Royal Collection, for example, is brimming with the canvases, sculptures and other pretty treasures gained from centuries of diplomacy. The custom continues to this day. When former British Prime Minister David Cameron first visited Washington he gifted President Obama a piece by street artist Ben Eine (born 1970). The President reciprocated by handing over a signed lithograph by pop artist Ed Ruscha (born 1937).

To advertise In 1985, drinks brand Absolut Vodka began approaching artists to help promote its product. The company bagged the biggest in Andy Warhol (1928–87), who provided a colourful screenprint of a vodka bottle. Many artists have since contributed to the long-running campaign, including such luminaries as Louise Bourgeois (1911–2010) and Damien Hirst (born 1965), but also many up-and-coming artists. It's perhaps the most famous venture between the worlds of art and advertising, but the two have a long symbiotic relationship. Think, for example, of the famous cabaret posters of Toulouse-Lautrec (1864–1901). Cheap prints of the same now hang in the bedrooms of a million students, but the posters were originally commissioned to sell theatre seats. Warhol, of course, took the relationship to a new level with his paintings of Campbell's soup tins and Pepsi lids. Salvador Dalí, meanwhile, appeared in adverts for Alka-Seltzer. This relationship continues to evolve. A recent trend, especially in large

cities, is the adoption of street art as a medium for advertising. Street artists can now make a living by creating murals to promote the latest running shoe or travel destination.

For local regeneration Before the arrival of the Guggenheim Museum in 1997, Bilbao was largely off the tourist map. Its opening brought in an estimated €500 million in just the first three years – a shot in the arm for the local economy. Art, especially when coupled with striking architecture, has the power to reinvigorate the place in which it resides. The so-called 'Bilbao effect' doesn't always work out, but there is no shortage of examples where an ailing post-industrial town has been given a fillip through such cultural investment.

To relieve oneself And finally ... if you still can't find a good use for art, you could put it to the most base purpose of all, and pee on it. That's exactly what numerous people have done to Marcel Duchamp's (1887–1968) famous urinal, *Fountain*, in what might now constitute an artistic tradition of sorts*. Some consider the act a work of performance art, creating a dialogue with Duchamp. Others are more blunt, offering their golden stream as a critique on the perceived stupidity of the work. Musician Brian Eno is the most famous Duchamp urinator. He claims to have peed onto the ceramic in New York's Museum of Modern Art in 1990, using a plastic tube to lengthen his reach (see pages 30–31 for more on *Fountain*).

* FOOTNOTE Though, as my publishers and their lawyers would want me to point out, not an artistic tradition that I would condone.

Primitive art is inferior to Western art

The term 'primitive art' is often used to describe creative works from societies that rely on ancient tools and techniques rather than modern technology. Does the word make you wince? It certainly has the whiff of judgment and cultural superiority about it. What counts as primitive is subjective, open to prejudice and largely a western construct. The term is still used by museums, galleries and auction houses, though alternatives such as 'tribal art' and 'ethnographic art' are now more common.

What counts as primitive? We might think of the ancient Greeks or Romans as primitive – they hadn't even invented cricket, for pity's sake – but as they tended to hang about in cities and farm crops, they are not considered primitive societies. Ditto the ancient Egyptians. Rather, primitive art must come from a culture that is closer to humanity's pre-civilization existence,

typified by hunter-gatherers living in small social groups in which everybody knows everybody else. Examples include Australian aborigines, indigenous American cultures and Pacific islanders.

There's a lingering notion that art from such societies is somehow backward or inferior to the great canvases and marbles of Western traditions. Can a cave painting compare with a Titian masterpiece? Is a decorated shield in the same league as a Michelangelo sculpture? This is to compare apples and oranges. Primitive art is rarely created simply to admire, or to demonstrate the artist's skill. It is bound up in ritualistic practice, community tradition and ancestor worship, or designed to appease the gods. To call it inferior (or superior) to other forms of art is meaningless.

The word itself doesn't help. In common parlance, that which is primitive is simplistic and out of date – an old way of doing something that we have long since surpassed. To live in primitive conditions implies poverty and wretchedness. It's not a word that toots the horn of positivity. When used in an art historical context, that's not really what's intended. It is more a handy label, to distinguish art created in tribal societies from that in more sophisticated, city-dwelling societies. But there's no escaping the pejorative tone of the word. Like the term 'Dark Ages' (see page 38–39), it is best avoided. For the rest of this section, I will use the phrase 'tribal art'.

The often unnaturalistic quality of tribal art adds to the prejudice. Humans and animals are typically represented with distorted or stylized features – much like in a child's drawing. Unrealistic does not mean inferior, however. If it did, we would place little value on much of the Modernist art of the 20th century. Movements such as Cubism and Fauvism trampled all over the idea that art must be lifelike (and there is a deeper link here, which we'll come to shortly).

Primitive societies often had no interest in realism, yet their creations can still astound. The famous terracotta sculptures of the Nok culture are a case in point. These intricate forms were carved in the centuries around 500BCE in what is now Nigeria. Their original purpose is unknown. Most depict humans, not with anything approaching realism, but with an assured flair nonetheless. Numerous further examples can readily be found in museums around the world – from Maori wood carvings to the hypnotic

patterns of the Incas. While such works might lack the technical expertise of a great Renaissance artist, they often pack an emotional or visual intensity equal to anything in the western tradition.

That said, some examples of tribal art are very sophisticated and even naturalistic. When we look at a ritual mask or decorated wooden figure, it is tempting to think that the people who carved them were not capable of lifelike sculpture or painting. This is not so. Several tribal cultures were perfectly able to produce realistic works. Perhaps the most famous were discovered in Nigeria in 1938. A series of brass heads (often erroneously described as bronzes) were unearthed during construction work in the ancient city of Ife. They are magnificent, and so naturalistic that many experts of the time were deeply confused at the discovery. Could these exquisite objects really be the work of an African tribe? Prejudice led some historians to suggest the heads were carved by ancient Greek colonists rather than any indigenous population.

Other cultures have produced similarly lifelike work. The Olmecs of Mesoamerica, for example, carved colossal and often lifelike stone heads around 1,000BCE. Cave paintings made by Australian Aboriginal artists sometimes depict the internal organs of animals. Even the ancient Egyptians – though not generally considered 'primitive' – dabbled with realism. Their idiosyncratic, rigid style of depicting humans and animals remained essentially unchanged for centuries, millennia even. Then, briefly, under the Pharaoh Akhenaten (who ruled directly before Tutankhamun), artists began to experiment with shape and form. Pharaoh Akhenaten and his wife Nefertiti were shown in much more naturalistic style. It lasted only as long as the king's reign before reverting back to the tried and trusted traditions of the past.

To some extent, I've been building up a straw man here in suggesting that tribal art is usually seen as inferior. While that idea may linger in some quarters, tribal art has now found a prominent place in Western galleries and is much better appreciated than in former times. It also played an enormous role in the development of 20th-century Western art. Giants such as Picasso (1881–1973), Gauguin (1848–1903) and Matisse (1869–1954) were heavily influenced by the tribal art they encountered in the galleries of Paris. Works such as Matisse's 1913 portrait of his wife and

Picasso's seminal *Les Demoiselles d'Avignon** are clearly inspired by non-Western art. This borrowing of motifs and styles from tribal art, common in the first decades of the 20th century, is usually known as Primitivism.

Such was the clamour for tribal art at this time that canny Africans began churning out artefacts (trinkets might be a better word) purely for sale to Western artists and collectors. This practice of 'manufacturing antiquities' continues today, and raises interesting questions of authenticity. If a member of a tribal society creates a traditional sculpture not for ritualistic reasons but purely for sale to the market, does it actually count as authentic tribal art?

* FOOTNOTE Picasso later denied that his celebrated canvas drew on African influences, instead citing ancient Iberian sculpture as his muse. There are good reasons to think he was telling fibs. Picasso is known to have visited – and gushed about – the African masks on show at the Paris Trocadéro around the time he was painting *Les Demoiselles*. And, I mean, just look at it.

A true work of art must be unique

One of the world's most famous works of art, seen by millions of people each year, is a fake.

Sort of.

Fountain, by Marcel Duchamp (1887–1968), was created in 1917. In form, it is simple – nothing more than an upturned urinal with the addition of a few pen marks on the side ('R Mutt, 1917'). In concept, it is much more complex. By submitting his 'readymade' work to an art salon, Duchamp was challenging the very notions of what art could be, simultaneously making us reappraise the form and function of an everyday object (everyday, that is, to half the population).

As avant-garde magazine *The Blind Man* put it at the time: 'Whether Mr Mutt made the fountain with his own hands or not has no importance. He CHOSE it. He took an article of life, placed it so that its useful significance disappeared under the new title and point of view – created a new thought for that object.' The upturned urinal may seem simplistic to the point of banality or mere jest, but it represents a revolution in artistic thought. *Fountain* has repeatedly been voted among the most important works of art of the 20th century.

And yet nobody has seen the original for a century.

Yes, you can view the urinal in London's Tate Modern. There it is again on floor two of the San Francisco Museum of Modern Art. There's another copy at the Pompidou Centre in Paris. *Fountain* exists in 15 different

versions around the world, all created many years after the original piece. Nobody knows what happened to the urinal. It was probably thrown out as rubbish soon after its creation in 1917. It was never exhibited, and few people ever saw this most influential of human artefacts. All that remains is a single photograph to prove that it ever existed. Next time you hear someone belittling Duchamp's urinal as 'a load of rubbish that anyone could have made', you can now out-sneer them by pointing out that it's not even the original.*

The story illustrates an intriguing side to art, which is not often considered. We like to think of creative works as unique – set down by the artist once and for all time. But a surprising amount of art has more than one form of existence. The practice of making numerous copies of a sculpture or print (known as artist's multiples) is common in contemporary art. One of the more eyebrow-raising examples is *Work no. 88, a sheet of A4 paper crumpled into a ball* by Martin Creed (born 1968). The artist made hundreds of copies of this work (which needs no further description) in the mid-1990s. At the time of writing, one of these masterpieces is on sale for £3,500 plus postage.

The idea of producing more than one version of a work is nothing new. Duchamp's very first 'readymade' – an off-the-shelf snow shovel given the enigmatic name *In Advance of the Broken Arm*, was also lost. It now exists as ten replicas. Sculptures are often cast multiple times. The most famous work by Auguste Rodin (1840–1917), *The Thinker*, can be viewed in dozens of museums, from Buenos Aires to Jakarta, with at least 25 in Europe alone. The same artist's *The Kiss* exists in three large-scale marble copies, numerous plaster casts, and hundreds of bronze casts – and that's just

* FOOTNOTE Of course, the more intellectual response would be to call it a pioneering work of conceptual art. 'It does not matter if the object is not beautiful or well crafted,' you could say. 'It is the *idea* behind it that is important. Nor should we care one fig if it's only a replica. It is the *idea* that is original, and the physical object before us is of no importance.' But where's the fun in that?

officially sanctioned versions created in Rodin's lifetime.*

A sculpture might be simpler to replicate, but paintings can also be duplicated or produced in multiple versions. It is quite common for a painter to make additional copies of his or her work or turn out a series of very similar variations on a theme. There are many reasons. Sometimes a work becomes so successful that the artist is commissioned to make further copies. Other times, the painter just fancies exploring a subject in subtly different ways.

Such duplication was common in medieval times, when artists would copy the same biblical scene for several clients. The practice continued into and beyond the Renaissance.

* FOOTNOTE The absolute record for most-reproduced work of classic art is probably the *Birth of Venus* by Sandro Botticelli (1445–1510) – that famous depiction of the naked goddess perched precariously on a scallop shell. A copy of the work (her head, at least) appears on the reverse of the Italian 10 cents coin, and is therefore carried around by millions of people. Other famous works of art feature on the remaining coins – for example, Leonardo's (1452–1519) *Vitruvian* Man graces the 1 Euro coin, while the 2 Euro carries Raphael's (1483–1520) portrait of Dante Alighieri (although these are minted in smaller quantities). Depending on your definition of art, more recent works such as the portrait of Queen Elizabeth II on British and Commonwealth currency, or even the design of a Coke can, could claim even wider circulation.

A 15th century Madonna and Child by Lorenzo Ghiberti (1378–1455), for example, was painted so many times that it could muster into a regiment. At least 40 copies, some of which have been tweaked or updated, can be found around the world. Portraits were particularly prone to repetition. Every noble would want to hang a portrait of the king or queen to display loyalty or sycophancy.

Later artists would continue the tradition. Take *Sunflowers*, by Vincent van Gogh (1853–1890). If I told you that this famous canvas had been destroyed in Japan during the Second World War, you probably wouldn't believe me. But it's true, at least partially. Van Gogh made four studies of the golden blooms, each called *Sunflowers*, in the summer of 1888. Two can still be seen in art galleries in Germany and England, one is in a private collection, and the fourth was burnt to ashes during a 1945 US raid on Japan – coincidentally on the same day as the Hiroshima bomb. The crop of genuine van Gogh sunflowers does not stop there. The artist made three close copies of the earlier works in January 1889. These now hang in Philadelphia, Amsterdam and Tokyo. So the work known the world over as *Sunflowers* is actually seven different paintings, six of which still survive.

This is not a unique situation. Edvard Munch's (1863–1944) most famous work *The Scream* exists in four alternative versions, two of which are works in pastel rather than paint. And then there's the curious case of Claude Monet (1840–1926) and his pond. The French artist created a famous painting known as *Water Lilies* in 1897. And again in 1903. And 1904. And many years thereafter. In total, some 250 versions of *Water Lilies* exist, most with the same or similar title.

Over time, even close replicas will start to vary in appearance. The pigments in a painting can fade or deepen on exposure to light. Temperature changes will form cracks in the surface. Restoration may further alter the tones. Duplicate paintings that are initially similar can look very different centuries later. You can see this in Leonardo's *Virgin of the Rocks*, which hangs in both the Louvre and London's National Gallery. The two versions were painted some 20 years apart, for reasons that remain obscure. They are reasonably similar in composition but, thanks to varying techniques of restoration, exhibit very different colours and tones.

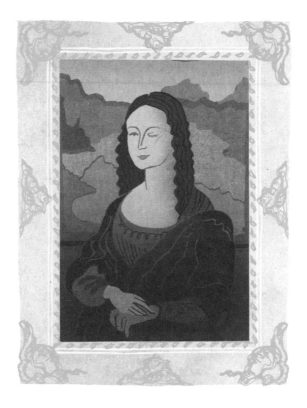

Even Leonardo's *Mona Lisa*, that seemingly unassailably one-off masterpiece in the Louvre, can be found in alternative versions. The so-called *Isleworth Mona Lisa* (named after the suburb of London in which it once resided) looks like something from a parallel universe. It's a *Mona Lisa*, all right. The lady is clearly the same sitter, in the same pose. Yet her fuller cheeks and rosier lips suggest a more youthful subject. The paintings also differ in background. Isleworth *Mona* lurks between two columns with an unfinished landscape behind, while her more famous sibling sits before a verdant wilderness. She's also painted on canvas while the Louvre masterpiece decorates a wooden panel. The origin of this alternative version is hotly disputed. It is thought by some to be the work of Leonardo himself, and may predate the more celebrated version. On the other hand, it might

simply be a copy by one of Leonardo's pupils, or someone else entirely. The jury is still out.

There are many, many further replicas of *Mona Lisa*. Most are clearly inauthentic and were painted after Leonardo's death. One particularly important copy hangs in the Museo del Prado in Madrid, Spain. This lady sports brighter sleeves and stands before a mountainous background, but is otherwise very familiar. She, too, was originally dismissed as a much-later copy. More recent analysis has suggested that she might be the work of Leonardo's workshop, and may have been painted at the same time as the original by one of the master's students.

Such cases raise the thorny question of attribution in art. As we've seen, many Old-Master paintings were made in multiple copies. The original might be largely the work of the big-name artist, but then additional copies could be made by his pupils or 'followers'. This is why we often see paintings labelled as 'by a follower of Rembrandt' or 'from the workshop of Titian'. The waters can get very muddy here. Quite often, a student might paint the majority of a canvas, which would then be finished off by the master. Or vice versa. It can then be very hard to define the authorship. Attributions are therefore dynamic. Paintings long thought to be the work of an artist's pupil are sometimes 'upgraded' to the master himself. Conversely, a painting can be downgraded by art historians if new evidence emerges, much to the chagrin of whoever just bought it at auction.

Modern and contemporary art pieces also raise questions of authorship and authenticity. Video art, for example, can be readily copied and displayed in many locations at once. This poses challenges for curators and collectors. Sculptural works increasingly make use of moving parts, electronics and visual displays. These will, inevitably, break down at some point. Is it still the same artwork if you replace the monitor, swap out a servo, or upgrade an operating system?

Even Minimalist sculptures are prone to such question marks. Carl Andre's (born 1935) notorious 1966 work *Equivalent VIII* physically comprises nothing more than a set of 120 firebricks, arranged in a rectangle on the floor. This seemingly harmless composition caused an uproar in 1976,

when the Tate acquired it with public funds. 'Waste of money' fumed the newspapers, igniting an angry debate about the direction of contemporary art. Two footnotes in this furore are perhaps more interesting than the art itself. The first is that the piece bought by the Tate was not the original. As with Duchamp's urinal, Andre had long parted company with the 1966 bricks and had to re-create his installation with a new set. Second, the Tate later found itself trying to source yet further replacement bricks, after a protester defaced the work with dye.

After a period in storage, *Equivalent VIII* is once again on show at Tate Modern. Visitors are not simply looking at a pile of bricks, they are looking at a pile of bricks that replaced an earlier pile of bricks, which were then partly replaced, disassembled, put in storage and then reassembled. What started out as a simple pile of humdrum building materials can now take us on an intellectual journey into the meaning of identity and the permanence of objects. It may not be pretty, but *Equivalent VIII* provokes more thoughts about the nature of art than many a fine canvas.

Between the ancient world and the Renaissance, art was effectively dead

Among the British Museum's countless treasures, there is one display that I return to time and again. The Sutton Hoo ship burial was discovered in the East Anglia region of England on the eve of the Second World War. It is among the most important archaeological discoveries in western Europe, shining a light on 7th-century society.

The Sutton Hoo helmet with its bronze and iron face mask has come to symbolize that era. But the rest of the hoard contains further wonders. I turn, particularly, to the pair of shoulder clasps, which would once have held together the front and back sections of ceremonial armour. They are magnificent – a masterpiece of gold filigree, inlaid with red garnets and blue glass. If you're lucky enough to be able to visit the clasps in person, you will never again think of the period they came from as the Dark Ages. Amid all the bloodshed, war and pillaging that characterize those times, the most incredible arts and crafts still blossomed.

Finds such as the Sutton Hoo treasure have done much to overturn prejudices about this period in art history. Until recent times, it was common to think of the millennium between the fall of the Roman Empire and the Renaissance (very roughly 400–1400CE) as essentially barren. Our terminology for the era reinforces that. The phrase 'Middle

Ages' was first deployed by historians in the 15th century to refer to the unpalatable sandwich filling between their own, modern times and the golden age of the ancient Greeks and Romans. The later term 'medieval' stems from the same mode of thought.

Then we have the phrase 'Dark Ages', usually applied to the earlier medieval period. It just sounds grim, doesn't it? A benighted time of superstition and

ignorance; dark and stupid compared to the days of enlightenment in which we now live. Well, the term is slightly more nuanced than this. 'Dark' can also mean obscured or hidden, and this is the sense intended by historians. The relative lack of written records after the fall of Rome makes it tricky to understand the cultures, and even basic chronology, of the ensuing centuries – and hence they are dark to us. The term is now gradually falling away as new facts come to light, while historians, novelists and filmmakers continue to reinforce the complexity and richness of those times.

The Sutton Hoo treasures are by no means unique. Many other examples of highly skilled artisan work have been found across Europe. The most impressive, perhaps, comes from the far east of the continent where the Byzantine Empire continued many of the traditions of Rome. Art in this part of the world went through many phases and styles, and most was religiously inspired. Byzantine art is particularly noted for its mosaics, panel paintings and icons, while intricate ivory carvings continue to dazzle. Art also blossomed during the reign of Charlemagne and his heirs (roughly 780–900CE) across the Frankish Empire. The Carolingians, as these people are known, also sought to revive Roman culture, with mosaics, statues, illumination and ivory carving. Many further examples could be explored. Even the so-called Vikings, notorious for their bloodthirsty, rapacious ways, were capable of crafting fine jewellery and extremely intricate wood carving.

Surely the most impressive art form to stem from the period, though, comprises the illuminated manuscripts created in religious houses. These are not only invaluable historical documents, but also objects of immense beauty. The Lindisfarne Gospels, crafted in north-east England very roughly around 700CE, is among the most celebrated; the twists and turns of its lettering are simply staggering. Some are drawn with such complexity that untutored modern eyes might suspect a computer algorithm had determined the intricate designs.

Architecture, too, was not entirely stifled during the medieval centuries. Quite the opposite. The great Gothic cathedrals – first conceived in France, from the late 12th century onwards – surpass anything the Romans

achieved in their soaring majesty, graceful engineering and sheer size. It's a little known fact that England's Lincoln Cathedral, completed in 1311, was the tallest building in the world for almost 250 years*.

Europe's medieval cathedrals not only flaunted an unprecedented scale of architecture, but they were also rich repositories of art and craft. These buildings are peerless testaments to human creativity: whether in the carving of rood screens, porches, fonts or pulpits, in the elaborate paintings on altarpieces, or the still-breathtaking glow of a stained-glass window.

When we look at painted art from these centuries, it's tempting to giggle at the naivety. Any 13th-century depiction of the Madonna and Child, for example, looks awkward and inferior when viewed alongside the same subject by Raphael (1483–1520) or Bellini (1430–1516). It's important to remember that medieval painters had very different motives to their successors. Theirs was a spiritual art, intended to inspire veneration and devotion. They had scant interest in realism, only symbolism. It didn't matter if the saints were painted with little depth or sophistication, so long as they all held the correct attributes, adopted the right poses and maintained their haloes at regulation height.

* FOOTNOTE If my editor might allow me a wild tangent here, then I'd love to share some other little-known superlatives of East Midlands architecture. Did you know, for example, that the small spa town of Buxton in Derbyshire sported the world's largest unsupported dome between 1881 and 1902? The Devonshire Royal Hospital's roof boasted a diameter almost 5m (16½ft) more than Brunelleschi's (1377–1446) famous dome on Florence Cathedral. It's still there, functioning as part of the University of Derby. Meanwhile, the famously flat county of Lincolnshire not only claimed the world's tallest building in Lincoln Cathedral, but also (much later on) the tallest guyed mast in the world. The Belmont transmitter near Market Rasen reached 387.7m (1,272ft) when completed in 1965, but has since been truncated and surpassed. I appreciate this is something of a sidetrack from the world of medieval art but – I hope you'll agree – deliciously interesting.

It's true that certain techniques, such as the rules for drawing in perspective, were not discovered until the Renaissance. In that sense, art did move on into more sophisticated realms. But to think of Renaissance art as an improvement on what came before is problematic. Art does not 'progress' in the way that medicine, science and technology progress. It merely shifts form, in reflection of the times. This is easier to see if we consider developments after the Renaissance. Few would claim that Picasso's work was an improvement on that of the Impressionists, who in turn reached greater heights than painters of the Romantic school. All took creativity in a new direction, but not one that might objectively be described as 'better' or 'worse'. So, too, with the gradual transition from medieval styles to Renaissance styles. Masterpieces that still beguile can be found in either era.

Another charge sometimes levelled at medieval art is that it's all a bit samey. For centuries, artists depicted well known biblical scenes, in very similar styles, with little innovation. This is a prejudice of the era we live in. It's natural to think that artists have always strived to be different, to create something original, to stand out from the crowd. For most artists, through most of history, this has not been the case. Especially among ancient civilizations, artists more often worked within a strict set of customs and stylistic conventions. The aim was not to produce beautiful, original art, but to carry on a tradition. This is most clearly seen in ancient Egyptian art. With few exceptions, you could take wall paintings from any century of their millennia-long civilization and find few differences in style. The same is true of medieval art. A trained eye can find different styles across territories and centuries, but there was nothing like the pace of change seen since the Renaissance. Again, this does not imply that medieval artistic traditions are inferior, only that they are different to those we've grown up with.

It should also be noted that not *all* medieval art was religious. Numerous scenes from courtly and military life can be found in the manuscripts of the time. Textile works often showed hunting scenes or military conquest, as in the Bayeux Tapestry, created in the 1070s. Great charts of the world known as mappa mundi were also produced at this time. Populated with exotic creatures and mythical lands, these are as much works of imagination as of cartography. In the early 13th century, the English monk Matthew Paris (c.1200–59) produced his own maps of Europe, along with the earliest

known drawings of elephants, and even a crossbill eating fruit. Much art of this sort has no doubt been lost or destroyed down the centuries, whereas religious art has enjoyed the relative sanctuary of churches and cathedrals.

It's worth remembering, too, that plenty was going on in the rest of the world during medieval times. While Europe struggled to emerge from its so-called Dark Ages, the Islamic world enjoyed what is often referred to as a Golden Age. From around the 8th to the 13th century, centres such as Baghdad (now Iraq), Cairo (Egypt) and Córdoba (Spain) became thriving hubs. Scholars here made important strides in mathematics, astronomy and medicine, while preserving the great written works of antiquity that might otherwise have been lost. But there was also a flourishing of the arts. Islamic artists were renowned for their skill with ceramics, glassware, metalwork, manuscript illumination and – most famously – calligraphy. Contrary to common belief, the painting of human forms was not entirely forbidden by Islam and, from the 13th century, a strong tradition of miniature painting emerged in Persia.

As with the cathedrals of the west, Islamic architecture reached impressive heights. The great mosque at Kairouan in Tunisia (7th–9th century) and the spiralling minaret of the mosque at Samarra in Iraq (9th century) surpass in magnificence anything constructed in Europe at the time, while the later Alhambra (13th century) in Moorish Spain remains a world icon.

China – to take just one more example from many possible – has enjoyed a long artistic history that has never suffered a collapse comparable to that seen in Europe. Here, a greater emphasis was placed on what Westerners might call the decorative arts, such as pottery and ceramics. China also has an exceptional tradition of painting and sculpture. The latter is now world famous thanks to the discovery in 1974 of the so-called Terracotta Army – thousands of individual soldier statues crafted in the 3rd century CE. Chinese painters were depicting landscapes and secular scenes as early as the 8th century, long before such traditions started in Europe.

Art is all about wandering around galleries

Straw man alert! To many readers, this proposition will seem so obviously untrue that it needs no debunking. 'Of course you don't need to visit galleries to appreciate art,' you might say. But I think that the association between the two is so strong that it deserves a little unpicking.

Art galleries, we'd all agree, are *extremely* popular.* Head to any of the world's major venues – be it the Prado in Madrid, MoMA in New York, the Hermitage in St Petersburg, the Louvre in Paris, Tate Modern in London or any of their ilk – and you face a metaphorical bun fight. Even though many charge high entrance fees, these great museums of art are always packed.

Yet survey after survey suggests that galleries are not *extremely* popular, merely popular. Only 20–25 per cent of the US population visits a gallery in any given year (see, for example, the Humanities Indicators survey of 2012, available online). By contrast, around 70 per cent of Americans visited the movie theatre at least once in 2015 (Motion Picture Association of America Theatrical Statistics). The numbers vary somewhat across countries, but the message is clear: most people don't visit art galleries.

There are many reasons for this. Some people live too far away from a gallery, or begrudge the entrance fee. But it's probably fair to say that most simply aren't interested. Galleries are not for them and, by extension, art is not for them.

But I'd like to poke around at the simplistic equation that says ART = GALLERIES. The 80 per cent of Americans who dodge such places are not all philistines. Art comes in many other formats, and an ever-increasing range of places. And if Instagram is anything to go by, we're all mad for it.

Any town or city dweller will, for example, regularly encounter public sculpture. The idea dates back to antiquity, when huge stone or bronze

* FOOTNOTE Here, I'm ignoring private, commercial galleries, which get a much smaller footfall. These intimate spaces are designed primarily to attract buyers, or raise the profile (and thereby commercial value) of a represented artist. As such, they can be a little off-putting. 'Am I dressed smartly enough?'. 'No one else is here – should I go in?'. 'There's no way I'm going to buy, so will I be welcome?'. Such concerns are almost always unfounded. Most small galleries are thoroughly lovely and happy to see you, whether you're there to buy or to browse.

likenesses of gods, rulers and generals would stand in important civic spaces. As a way of presenting art, the public sculpture almost certainly pre-dates the public gallery. It's also more popular. Because of its highly visible nature, public sculpture is usually viewed by more people than any gallery space. The statue of Nelson and the four lions who guard his column in London's Trafalgar Square, for example, are seen by many more people than any of the fine paintings hanging in the adjacent National Gallery.

In recent decades, traditional statuary has been supplemented with other forms of art, such as the abstract shapes of Henry Moore (1898–1986), Barbara Hepworth (1903–1975) and Anish Kapoor (born 1954). The streets and plazas of our cities are now enlivened with a whole range of sculptural styles, the match of any gallery. Indeed, one could argue that freeing art from the gallery space adds a new dimension. Works can be site-specific, reacting and contributing to their surroundings in a way that isn't possible inside the standard white cube of an indoor exhibition. The balloon dogs of Jeff Koons (born 1955) are far more striking in the open, where the mirrored surfaces reflect sunlight and surrounding buildings, than they could ever be inside a gallery. Antony Gormley's (born 1950) great *Angel of the North*, beside the A1 road near Gateshead, England, wouldn't even fit into a normal gallery. If it could, it would lose its sense of monumentality, and its value as an icon of north-east England.

Public sculpture is not the only form of art to bypass the gallery. Street art, as the name implies, is also ubiquitous in most large cities. I know many people who are passionate about this form of art, but who would rarely set foot in a traditional gallery.* As with public sculpture, street art is often highly site-specific. As an art form, it is also highly variable, short-lived, typically political or humorous and often in a familiar location – all of which, I'd wager, makes street art the most photographed form of art in the world, aside from architecture.

* FOOTNOTE That said, street art has become increasingly commercialized in recent years. Most of the top practitioners now display (and sell) their works in gallery shows just like traditional artists (see page 125).

Street art has spawned any number of subdisciplines. One of the more intriguing is guerrilla art, which uses the urban environment for inspiration. This is a form of creativity that could never truly work in a gallery. The artist Ben Wilson (born 1963), for example, hand-paints pictures onto discarded gobs of chewing gum – he's even been arrested for his efforts, on suspicion of criminal damage. On a similarly diminutive scale, artists like Pablo Delgado (born 1978) and Slinkachu (born 1979) leave minute paintings or models around the city that only the sharp-eyed will spot. Their characters interact with manhole covers, pieces of litter or tufts of dandelion growing through the cracks in the pavement. Meanwhile, yarnbombers decorate lamp posts and chain fences with knitted interventions. My personal favourite bit of guerrilla art was the 'spudnik' craze, rife in London around a decade ago. The person or persons behind this project painted gaudy colours onto potatoes, pierced the tubers with wooden spikes, and then hurled them on top of bus shelters. Only those riding on the upper deck of a bus would ever see these curious creations. There's a certain kind of genius in that.

Some artists even involve the public in their work, and here the figure of Spencer Tunick (born 1967) looms large. His speciality is the artistic arrangement of naked humans. In 2004, he made headlines after filling a street in Cleveland, Ohio, with a pink carpet of reclining nudes. Actual nudes. Men and women drawn from all sections of society, willing to shed their clothes to be part of an artwork. Such fleshy gatherings are a clever nod to art history, while also probing our attitudes to public nudity and privacy. Tunick persuaded an even greater number of metropolitan naturists onto the streets of Hull, England in 2016. Every participant was painted head to toe in blue. The effect was stunning, and far more memorable than your typical oil-on-canvas.

Examples like those outlined above are seen and appreciated by millions, many of whom would not set foot in a traditional gallery space. Such works are often among the most visible, the most photographed and the most talked about examples of art, and they come with no entrance fee. Yet when we think about art, how many of us immediately consider such varieties? Ask a friend to give you the first word or phrase that enters their head when you say 'Art'. Chances are they'll say 'gallery' or *Mona Lisa* or 'Picasso'

rather than 'naked Cleveland people' or 'spiky potato'. The prejudice that ART = GALLERIES persists in nearly all of us. I suspect that will be the case right up until someone figures out how to make serious money from non-gallery art.

An entire book could (and absolutely *should*) be filled with further examples of ways to see art outside of a gallery. I haven't yet mentioned land art, illuminations and projections, tattoos, digital arts, corporate art and, of course, the associated worlds of design and crafts. In addition, numerous projects around the world now seek to place traditional art in non-traditional settings, such as the Rome's Centrale Montemartini Museum, which secretes classical Roman sculpture around the hulking machinery of a former power station. Nor have I covered the many alternative ways of appreciating traditional arts without going to a gallery – from art books to prints to high-resolution digital scans. It seems blasphemous to say it, but one can learn more about art from half an hour browsing a well-curated website than from a half day spent in a gallery – although you're unlikely to get the same emotional connection to the works.

The advent of mainstream virtual reality and other technologies offers a further opportunity for those who can't or won't visit a gallery. Many venues already provide virtual tours of their holdings, albeit via a clunky, mouse-clicky experience. Once this is coupled to a decent VR headset, we'll be able to tour the world's great galleries at leisure, without that off-putting bun fight. Or imagine an app that uses the kind of augmented reality made popular by Pokémon GO. We could all be heading out to the countryside in search of Corots and Constables virtually hidden up trees, or digitally fishing the waterways for hidden Canalettos.

Hang on – I think I just found a way to make money from non-gallery art.

Women couldn't make a career out of art until the 20th century

Anyone who pays attention to art could probably name plenty of female artists. Louise Bourgeois (1911–2010), Tracey Emin (born 1963), Maggi Hambling (born 1945), Barbara Hepworth (1903–75), Frida Kahlo (1907–54), Georgia O'Keeffe (1887–1986) and Bridget Riley (born 1931) are just a handful of household names from the 20th and 21st century. While the art world remains conspicuously male-dominated, it has long been possible for women with talent and persistence to make a mark, and often a living, from their work.

It's much harder to conjure up a list of famous female artists from earlier centuries. As with most professions, women were largely discouraged from the paint brush and the chisel for much of history. That's not to say that there weren't women artists, but few were celebrated as such in their own times, and still fewer could earn much financial reward from their talents.

In many cultures, women have traditionally been associated with the decorative arts and crafting, rather than the so-called 'fine arts' like painting and sculpture.* For example, the Bayeux Tapestry and other stitched marvels of the Middle Ages were largely produced by women, although the underlying patterns may have been drafted by men. In later centuries, women could make a living from art as auxiliaries – through frame making or modelling, for example. But as artists in their own right? A tour around any gallery of historic art will not yield much evidence, nor will a glance at the top auction sales.

There are, however, plenty of notable counterexamples if one takes the time to look beyond the familiar narratives of art history. In fact, the very origins of the arts are often associated with female figures. We might think of the Greek Muses, who inspired poetry and music (though usually in men). The invention of drawing, and with it much of fine art, was attributed by Pliny the Elder to Kora, the daughter of a famed Greek potter named Butades. Kora recorded the shape of her lover's face by tracing his shadow; the image was then modelled in clay by her father.

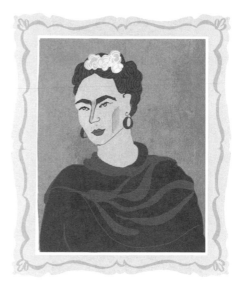

Kora was mythical. What about genuine women artists? The truth is that no period of artistic history has lacked female talent. Even during medieval times, women (usually nuns) contributed to the illumination of manuscripts, as well as creating tapestries and embroidery. Their names are unrecorded, as was the tradition for male artists of the time.

After the Renaissance, individual artists come to the fore. One of the most talented (and, these days, reasonably well celebrated) is Artemisia

* FOOTNOTE This division between fine arts and decorative arts is laden with historical snobbery. Painting, drawing, sculpture and – to some degree – photography, have long been considered superior forms of art to crafts like making jewellery, glass and ceramics. The practitioners of the former are called artists; of the latter, artisans. This is a Western prejudice, with its roots in the Renaissance. The decorative arts have enjoyed much higher status in other eras and other cultures.

Gentileschi (1593–1656), an Italian painter of scenes from myth and the Bible. Both she and her father Orazio were heavily influenced by Caravaggio (1571–1610). You can see it, for example, in the strong contrast between light and dark that is a recurring feature of her paintings. But Gentileschi was no mere Caravaggio wannabe. Her works have a striking dimension of their own. She depicts the struggles and triumphs of women, at a time when most representations of her sex were meek or titillating. Her canvases are always arresting, both in subject matter and composition. The most famous shows the bloody beheading of the general Holofernes at the hands of Judith (an oft-painted incident from the Old Testament). The scene is truly horrific. Yes, there's gore, but the real chill comes from the calm demeanour of the murderer and accomplice.

Gentileschi's talents saw her rise to high status. She became the first female member of the Accademia di Arte del Disegno in Florence. She also served as a court painter to the Medici family, and travelled to England to work on commissions for Charles I. Gentileschi's superstar status* is so great that we're in danger of labelling her the only successful female painter of this era. Not so. Decades earlier, Sofonisba Anguissola (1532–1625) became an official court painter to Philip II of Spain. Lavinia Fontana (1552–1614), a gifted painter of portraits and biblical scenes, was also the main breadwinner for her large family. Fede Galizia (c.1574–c.1630) made a living from portrait commissions, but is better known today as a pioneer of exquisite still lifes.

These Italian painters opened the way for other women to pursue an artistic career. The next generation saw two successful portrait painters, Mary Beale (1633–99) and Joan Carlile (c.1606–79), both able to make a living from their profession. Beale was one of the first women to write an instructional book about painting. Her pupil Sarah Hoadly (1676–1742) was also celebrated, and her work still hangs in Britain's National Portrait Gallery.

* FOOTNOTE Her turbulent life has been the subject of several novels, and the film *Artemisia* (1997).

Further important painters can be identified in the next century, and particularly in France. Foremost among them was Louise Élisabeth Vigée Le Brun (1755–1842). Vigée Le Brun is best noted for her court paintings in the run-up to the French Revolution, including 30 Rococo-style portraits of Marie Antoinette. She was admitted to the French Royal Academy of Painting and Sculpture on the same day as her fellow portraitist Adélaïde Labille-Guiard (1749–1803). Vigée Le Brun left over 800 canvases, many of which hang on the walls of the world's most prestigious galleries.

Have you noticed how the word 'portrait' keeps appearing in this discussion? Until the late 19th century, most societies banned women from studying anatomy. Nor could they sit in art classes and sketch a male nude. It was unthinkable that a woman might be exposed to such sights. The men, clearly made of sterner stuff, were seldom dissuaded from studying a female nude. This made it tricky (but not impossible) for women to gain commissions for works featuring posed bodies, other than in a formal portrait setting. Partly for this reason, women artists of these centuries tended to excel in portraits, landscapes and still lifes.

The 19th century brought greater access to training for women, but still with restrictions on what they could study (i.e. no nudes, please). These decades saw a marked increase in the number of women who were able to exhibit works at academies and galleries. Some trod new creative ground. Berthe Morisot (1841–95), Marie Bracquemond (1840–1916) and Mary Cassatt (1844–1926) all made important contributions to Impressionism, for example, and are still appreciated today. Morisot's *Après le déjeuner* (1881) sold at auction for a cool $10.9 million in 2013.

Women also found freedom in the new art of photography. Lacking any stuffy traditions or formal oversight, the medium was fair game for anyone with the means to buy equipment. Geneviève Élisabeth Disdéri (1817–78) was an early professional, running a daguerreotype studio from the late 1840s and making her own important photographs of architecture. Around the same time, Bertha Beckmann (1815–1901) became Germany's first professional female photographer, and one of the first anywhere to exhibit her photographs. As the century progressed, women would play as important a role as men in developing photography into an art form.

The 20th century saw a seismic shift in the attention paid to women artists. As the decades went on, women not only demanded more space on gallery walls, they also took art in bold new directions. The big names who opened this section are only a small selection. Many of their stories are told elsewhere in this book.

A couple of decades into the 21st century, it's tempting to believe that there is now equality in the art world. Gender and race should pose no barrier to success if you are an artist of talent. While great strides have been made in many countries, there is still a lingering favouritism for the art of white males – even in contemporary art, which shouldn't have the hangovers of the male-dominated past. We'll end this section with some telling statistics (accurate in January 2017), which show just how much of an imbalance still remains.

- Highest price paid for a painting by a man: estimated **$300 million** in 2015 for Willem de Kooning's *Interchange* (1955). Highest price paid for a painting by a woman: **$44 million** in 2014 for Georgia O'Keeffe's *Jimson Weed/White flower No. 1* (1932)
- Of the top 75 most expensive paintings ever sold, the number painted by women: **0**
- Of 590 major exhibitions by nearly 70 institutions in the USA from 2007–13, the percentage devoted to women artists: **27 per cent***
- In the 2016 'Power 100' survey by ArtReview, which lists the art world's most influential figures, the percentage who are male: **68 per cent***
- Of 101 European museums who responded to a poll, the number that have 40 per cent or more women artists in their collection: **2***

* FOOTNOTE Statistic publicized by the Guerrilla Girls, a long-running campaign group who seek equality in the arts.

True artists should do the work themselves

In 2010, London's Tate Modern Turbine Hall played host to *10 million* new sculptures. Each was unique. These tiny nuggets of porcelain were sculpted and painted by hand. They might justifiably be considered individual pieces of art in their own right but, brought together, they formed a great, grey carpet across the gallery floor in a work known as *Sunflower Seeds*.

The installation was created by the Chinese artist Ai Weiwei (born 1957). Here, 'created' is a debatable word. Ai Weiwei might have dreamt up the spectacle, but it would have taken a lifetime for him personally to produce each seed. Instead, he relied on more than 1,600 sculptors and painters to realise the work on his behalf.

To some, this provokes a criticism of contemporary art. The traditional artist was judged on his or her technical ability. Now, it's all about management and direction, as an army of lackeys do the drudgery. Ai Weiwei is not alone. The world contains over 1,400 Damien Hirst (born 1965) spot paintings, but only a handful were painted by Hirst himself. Bridget Riley (born 1931) has produced any number of abstract canvases. Their eye-bending geometries are terrific to admire, but surely laborious in the extreme to paint. Hello, assistants! Andy Warhol's (1928–87) production line, The Factory, churned out silkscreens, lithographs and films.

The role of artist's assistant goes back way beyond modern and contemporary art. Michelangelo's (1475–1564) achievements in the vaults of the Sistine Chapel were supported by numerous helpers, who handled much of the colouring and background. Rembrandt (1606–69) maintained a large workshop, where assistants not only carried out much of the graft,

but also had to pay for the privilege of working alongside the master. The sculptor Rodin (1840–1917) would typically prepare sketches and clay models for his next piece, and then leave it to others to carve out the finished work in marble or make a cast in bronze. There are countless other examples (and, of course, counterexamples) throughout the history of art.

There is a key difference here, though, between the assistants of the past and the kind of support work employed by Hirst and his team. Those who helped to create the Rembrandt and Rodin masterpieces were learning advanced skills that would stand them in good stead to form their own studios. By contrast, those assisting today are often engaged in relatively menial, unskilled tasks – the artistic equivalent of an office internship. It's a foot in the door rather than a foot hewn from Carrara marble.

To some critics, any assistance is too much assistance. It plays havoc with our romantic notions of what an artist should be. The idea of the lone genius, both conceiving and executing a masterpiece is infinitely more seductive than a group of anonymous hirelings working under the direction of an absent manager. Unfortunately, that rarely reflects reality in art or other disciplines. A Norman Foster skyscraper may bear the big man's fingerprints, but the details of its structure are the work of dozens if not hundreds of employees and contractors. We'd all think of Steve Jobs when asked to put a face to the iPhone, but the kit was designed and built by an

army of specialists, not all of whom would be known to one another, or to Jobs. We may remember the name of a great, Nobel-winning scientist; we do not recall, or ever hear of, the many researchers who carried out the key lab work. Nobody expected Gene Roddenberry to personally pen every episode of *Star Trek*, nor Vince Gilligan to jealously hoard each script of *Breaking Bad*. So why shouldn't the Hirsts, Rileys or Rembrandts of this world also share their creative practice with others? It's a complex question, raising issues of authorship and originality, but it is certainly not a recent one.

Then, too, it would be wrong to assume that *all* contemporary artists go down the route of hiring assistants. Many do not. Ahead of a 2012 exhibition, David Hockney (born 1937) released a statement declaring: 'All the works here were made by the artist himself, personally'. It started a fresh wave of debate about the role of the assistant in contemporary art.

In the end, it all comes down to context. Ai Weiwei's sunflower seeds could not have been assembled by one artist alone, and to give all 1,600 creators an equal billing would raise its own problems. Assistants are a necessary and valuable part of the art world, and always have been. At the same time, not all forms of art would be credible if left to an assistant. We would feel cheated if the moody, personal visions of the Impressionists turned out to be a team effort.

Painting

From the cave art of our ancient ancestors to the
abstract paintings of the modern era.

The oldest art in the world can be found in the caves of Lascaux in France

It would be an understatement to say that the summer of 1940 was a dark time for France. The north of the country was under direct Nazi occupation; the south was forced to genuflect. Tens of thousands had lost their lives in an attempt to defend the realm. It was the most unlikely hour and place for one of the world's greatest artistic discoveries.

A group of teenage friends were taking a walk in the woods near Montignac in the Dordogne. The boys were searching for a rumoured secret passage into a local chateau. They certainly found a hole, but one that led to cultural riches far surpassing anything to be found in a vicomte's basement.

Having widened the small aperture, the boys descended a shaft into a cave filled with the most beguiling art. They discovered a painted menagerie that included species long-vanished from the woodlands above: horses, stags, cattle, birds, bears and rhino, clearly prehistoric. This was an extremely important find. Other cave art was known in the area, but the Lascaux pictures were better preserved, and more impressive. These caves had been sealed from the elements for 17,000 years. It took the chance event of a falling tree to uproot some earth, expose a hole and attract an adventurous band of teenagers. They became the first humans to see these imagined creatures for 850 generations.

The Lascaux paintings are not crudely drawn graffiti, but sophisticated artworks. The beasts are often shown in motion, with limbs in perspective. One bull is over 5m (16½m) long. Larger than life, it outmeasures any other known cave depiction of an animal. The scenes are embellished with abstract dot and lattice patterns. Some say these are star charts, or representations of hallucinogenic states. They might equally be an artistic whim. Other forms are painted onto an inaccessible ceiling. The use of scaffolding is implied. We do not know why the cave dwellers chose to decorate the space in this way. We do not know the artists' names or if they even had names. We can but guess at whether they were male or female, young or old. And we can only boggle at the artistic sophistication.

After the Second World War, the site was opened to visitors. Many made the pilgrimage. It was soon discovered that the cave walls were highly sensitive to human presence. The increased humidity from an incessant flow of tourists encouraged moulds, moss and fungus, which put the images in danger. They may now only be viewed in replica, at a nearby visitor centre. The original paintings are among the world's most important, yet least-viewed artworks.

The Lascaux animals have to be the best-known examples of truly ancient creativity. They have been dubbed the 'cradle of man's art', and are often assumed to be the world's oldest known paintings. They're not, though. Not by a long chalk. Even older animal forms were discovered in 1994 elsewhere in France, in a cave to the south-east in Chauvet. Here, antediluvian artists scraped away at the walls to provide a smooth surface before applying deft representations of predatory beasts. How long these creatures have lain dormant, awaiting human eye, is debated. The best guess is 30,000 years – almost twice the age of Lascaux. The most recent data suggest the earliest images go back 37,000 years. They remain less famous than the Lascaux works, owing to their more recent discovery. The public have never been granted access to the caves. As with Lascaux, you can see a re-creation in a nearby visitor centre.

Further discoveries have pushed the origins of creativity still further. A red dot in a cave of El Castillo in Mexico has been reliably dated to around 40,800 years ago. Sculptural art has similar antiquity. The so-called

Venus of Hohle Fels, uncovered in 2008, depicts a chubby female form in mammoth ivory. It is one of many figurative human and animal sculptures from southern Germany, and might be 40,000 years old. Its shaping required hundreds of hours of work: in other words, this wasn't tossed out by someone idly playing with a tusk – the crafter possessed clear skill, patience and a sophisticated appreciation of three-dimensional form. There is much speculation about why these figurines were carved, but nobody really knows.

It was long thought that this first blossoming of art was unique to Europe. Recent research in Indonesia seems to have overturned that view. Cave

paintings of animals and hand prints on the island of Sulawesi were initially dated to 10,000 years ago. Then, in 2014, a team of scientists was able to assess the artwork more accurately using uranium-decay methods. Their conclusion: 40,000 years. That would make the paintings contemporary with the Spanish cave dot and German figurative sculptures, and a little older than the Chauvet animals.

The discovery, if correct, rewrites the history of ancient art. It had always been assumed that Europe exported its artistic awakening to the rest of the world. But now we know that humans were painting their caves thousands of miles away at the same time, or even earlier. This suggests two possibilities. Separate groups, on opposite sides of the planet, might independently have felt an urge to paint. Alternatively, and more likely, both groups split from an earlier tribe, which had already developed the skills. No direct evidence has yet been found, but it's tempting to speculate that the origins of our creativity will eventually be traced back to Africa or the Middle East, from where modern humans first migrated 60,000 years ago.

There's another twist to this story. Increasing evidence suggests that modern humans are not alone in our desire to create. Many believe that Neanderthals were also capable of artistic expression. The most persuasive example was found in a Gibraltar cave in 2014. Here, an ancient Neanderthal had inscribed an abstract pattern* onto the wall. The image has been dated back at least 39,000 years – older than Lascaux or Chauvet. Can a criss-cross grid on a cave wall, carved for unknown reasons, be called art? Some would say so; others, not. In any case, it's evidence that Neanderthals were scratching complex symbols onto walls before our own species had even arrived in the region. The red dot of El Castillo may also turn out to be Neanderthal.

Evidence for the oldest form of art may be pushed backwards still further, by as much as three million years. This was a time before modern humans,

* FOOTNOTE To the delight of news editors and cartoonists everywhere, it looks a little like the hashtag symbol commonly used on Twitter.

when various forms of upright ape roamed the lands of Africa. In 1925, an amateur archaeologist was surveying a cave in the Makapan Valley of South Africa. Alongside the bones of the ape *Australopithecus africanus* he found a remarkable stone. What came to be known as the Makapan Pebble is a red-brown jasperite, just the right size to fill a palm. It contains a series of marks that look a little like faces. These patterns were formed by erosion, and not the swivel of simian hand. Nevertheless, the pebble seems to have been deliberately carried to the cave from a riverbed. Did an *Australopithecus* see significance in the stone's face-like contours? It is the earliest indication of self-awareness, and a tendency to see patterns in natural features. The modern human brain is very good at this. Witness the never-ending procession of news stories about people who see faces on Mars, or on the surface of toast.

So an ancient hominin spotted a stone that looked like a face and was sufficiently moved to carry it back home. How is that art? Some have compared the stone to one of Marcel Duchamp's (1887–1968) 'readymades' – an object, most famously his urinal, that has no great significance until someone comes along and declares it important. Likewise, the pebble was just one of millions sitting around in a river until a keen-eyed proto-human deemed it significant.

There's certainly a debate to be had here. Even the British Museum, where the pebble was recently put on display, got itself a bit tangled over the issue. The exhibition to which it belonged was initially to be called *South Africa: Three Million Years of Art*. This was later watered down to *South Africa: the Art of a Nation*, presumably after internal debate about the 'A' word.

Whether the Makapan Pebble counts as art or not is really to miss a much more interesting point. That we can intuit the behaviour of an individual animal who died three million years ago; that we can deduce a fundamental human quality, a creative mind, so long in the past; these are more wondrous notions than any debate over definitions and semantics.

Still-life paintings are dull and unimaginative

It's easy enough to ignore the still-life paintings when walking through a gallery. Compared to a bloody depiction of Salome receiving the head of John the Baptist, or a stormy seascape by Turner, who'd want to stand in front of a bowl of fruit? Many still-life paintings look almost too real – it's like looking at a photograph. Boring!

There's a lot more to it than that, of course. What you see is not always what you get. Take those most popular of still-life subjects: flowers and fruit. Anyone with a seed of botanical knowledge might raise a questioning eyebrow at many of these works. Artists would commonly take a full year over such a painting so that they could incorporate blooms, berries and nuts from different seasons*. The painting therefore shows us an impossible collection. In some ways, then, the harmless bowl of fruit is a creation every bit as fantastic as the birth of Venus or van Gogh's starry night.

Still-life paintings might better be described as still *lives* paintings. Many are composites, painted from different displays at different times. Some artists would repeat the same flower or fruit across many paintings, to speed up production for an eager market. Tulips, often found in Dutch paintings, were for a long time prohibitively expensive, so copybook artifice had to be used to paint an entire bouquet.

* FOOTNOTE Some artists, such as the Dutch painter and botanist Rachel Ruysch (1664–1750) would alternatively make use of carefully preserved flowers, enabling them to paint an unnatural bunch in one go.

The humble still-life painting can also harbour a trove of hidden meanings. Grapes might be a sign of fertility or, as the source of wine, a symbol of the blood of Christ. Peaches mark fecundity while lemons betoken fidelity. Apples and figs, retaining their biblical roles, suggest temptation and modesty respectively. Then again, sometimes a pear really is a pear, and there is no symbolism beyond the painter's wish to show off her skills.

One particular species of still life, popular in the 16th and 17th centuries, deals with themes of death and the fragility of the body. 'Vanitas' paintings, as they're known, often include fairly obvious hints at mortality. A skull is not subtle, and nor is a sand timer. Look out, too, for a snuffed candle or decayed fruit. A butterfly might signify the brevity of life, or the Resurrection of Christ. A musical instrument may remind us of the ephemeral nature of our earthly existence. We fiddle for a while, pluck a few strings, and then our tune is up. A particularly good example is the *Vanitas-Still Life* (1668) by Maria van Oosterwijck (1630–93), which includes most of these motifs and more besides.

Caravaggio (1571–1610) is often credited with resurrecting the genre of still life, which had been in long slumber since classical times. His *Basket of Fruit* (c.1559) places apples, grapes, figs, a quince and peaches (all summer fruit) in a wicker basket on a ledge. It is an image loaded with secret meanings, at least according to some art historians. Almost every morsel in the bowl suffers from some form of blight, infestation or decay. Symbols of vanitas, perhaps, but some think Caravaggio was having a dig at the state of the church. His later *Still Life With Fruit on a Stone Ledge* (1605–10) is a riot of suggestively twisting marrows and succulent pink fruits whose lewd symbolism would be evident to the average teenager.

The history of still life is as intriguing as any other genre of art. In some ways, it's among the oldest form of painting. As noted previously, ancient Egyptian tomb walls would often be festooned with images of ripe fruit, vegetables and crops. The consumables would provide the dead with supplies on the journey to the afterlife. In a later age, the Romans decorated their homes with realistic paintings of fruit and wine. With the rise of Christianity, though, western artists shied away from still life. The role of the artist was almost always to provide scenes from the Bible. If fruit intruded at all, it was in the form of Eve's apple or the pomegranate as a symbol of Christ's Resurrection. Even into Renaissance times, still life was regarded as the lowest rung in the hierarchy of painting.

Christianity later spurred a resurgence in the genre. The rise of Protestantism brought a wave of distaste for visual depictions of Christ and his disciples – after all, hadn't the Bible forbidden the worship of idols and images? Painters in Protestant countries – particularly the Dutch – turned to profane topics. If you spot a painted bowl of fruit from the 17th century, chances are it'll come from a Dutch brush. One notable exception, though later, is Frenchman Jean-Baptiste-Siméon Chardin (1699–1779) whose mesmerizing still lifes often contain a hint of tension (see *The Ray*, 1728). Despite the popularity of still lifes in these centuries, the genre continued to play second fiddle to other forms of painting.

The late 19th century saw a revival by the singular talent of Paul Cézanne (1839–1906). His tricksy habit was to paint still life in impossible perspective. A table top tilts at an alarming angle; bread rolls are seen from the top and the side simultaneously; a cluster of apples looks certain to

tumble onto the floor. Cézanne showed how we truly see the world, not how we think we see it. A traditional still life depicts its subject in perfect perspective, seen from one unchanging position at one moment in time. But when we view an object in real life, our head may bob and our eyes will scan. We receive information from more than one angle. It was an ingenious insight, which paved the way for Cubism and other artistic movements. More importantly for present purposes, Cézanne's strange fruit are yet another example of how still-life paintings need not be a boring, nor slavish copies of what is before the artist.

I hope I've shown that still lifes are neither dull nor necessarily painted exactly from life. Even if the artist has made a faithful copy, then why not take the time to get a really good eyeful? We are surrounded by objects that we never take the trouble to study carefully. Besides a quick scan for blemishes, do we ever truly ponder the apple? Why does the skin change tone towards the stalk? What makes one side more red than the other? What are the small white speckles that play across the skin? There's a whole world in that apple, if only we take the time to look. Still-life painting encourages us to examine deeply, and reappraise objects that are so familiar as to be invisible. That's surely a more worthwhile pursuit than examining a decapitated saint.

Caravaggio changed painting forever with his candlelit scenes

Anyone dabbling with Old Masters for the first time can get a bit daunted. While the gallery veteran can readily tell a Titian from a Rubens from a Rembrandt, to the newcomer's eye, they can all get a bit samey – all those swooping cherubs, swirling robes and inexplicably exposed breasts. Caravaggio (1571–1610) was different.

The Italian painter stands out from his peers for many reasons, one of which is his temperament. It's no secret that he was a loose cannon, notorious for attacking his rivals both verbally and physically. Caravaggio has a police record like no other artist, and was forced into exile after killing (perhaps murdering) a young man in Rome.

As he lived by his own rules, so too did he paint by them. While his contemporaries couldn't get enough exposed breasts into their paintings (Rubens, I'm looking at you), there is not a single female nude in any of Caravaggio's paintings. Then again, his model for the Virgin Mary was a local prostitute. He never, so far as is known, attempted a fresco. He only signed one painting (the signature is well hidden in the blood of a beheaded saint). Unlike his peers, he left no sketches, and very few portraits. This is a painter who refuses to rest in any box. But it is his intense use of contrast – a technique known as chiaroscuro – that really attracts the eye.

In a typical composition, the faces of his figures are brightly lit from one side, while the background is in deep shadow, and sometimes pitch black.

The results can be heart-stopping; often intimate and menacing at the same time. Caravaggio was not the first painter to use the trick, but he took it to a new level of intensity and realism. This dramatic use of illumination set him apart from those who came before, like an Elvis among crooners. He is the master of candlelight.

There's a peculiarity with his candlelit scenes. Not a single painting by Caravaggio features a flame. Nor, when you think about it, are the sharp contrasts even suggestive of candlelight. The beams are too powerful, the illumination too harsh and directional to come from a flickering wick. These are depictions of bright sunlight intruding into dark places.

Caravaggio died in 1610.* His distinctive style had already attracted many followers, like moths to his non-existent flame. Dutch and Flemish artists, in particular, had a posthumous crush on the tempestuous Italian. Painters such as Hendrick ter Brugghen (1588–1629), Gerard van Honthorst (1592–1656) and Adam de Coster (1586–1643) carried on the tradition with flare, and occasionally with candle. The striking *Christ Before the High Priest* by van Honthorst (c.1617), for example, puts the candle flame at the central focus.

Within decades, Caravaggio had fallen out of fashion. Given his towering reputation today, it is surprising to learn that he was all but forgotten until his work was reassessed in the early 20th century. Today, any of his 80 or so surviving paintings will light up an exhibition; though not with a candle.

* FOOTNOTE Caravaggio's final days were also marked with intrigue. The artist died suddenly in 1610, aged just 38. The cause was not recorded. Suggestions include malaria, an intestinal infection, lead poisoning, infected wounds from a knife fight, syphilis and murder at the hands of one of his many enemies (even the Vatican and Knights of Malta have been implicated).

The Impressionists were the first to truly paint outdoors

Monet's (1840–1926) canvas *Impression, Sunrise* (1872) is definitely a grower. On first glance, it looks a bit, well, scruffy. Shades of grey, blue and orange have been ushered onto the canvas in what seems a haphazard manner. A trio of increasingly ill-defined rowing boats recede from the foreground. The closest we get to detail is in the artist's signature. It's as though the painting is unfinished.

Critics thought so too. *Impression, Sunrise* was first shown in 1874 at one of the most famous exhibitions of all time. The 30 participants included such notables as Monet, Degas (1834–1917), Pissarro (1830–1903), Renoir (1841–1919) and Sisley (1839–99), though none was well known at this point. Monet's painting was singled out by reviewer Louis Leroy. In his withering judgement, 'A preliminary drawing for a wallpaper pattern is more finished than this seascape.' Many other works in the exhibition showed a similar loose style, with visible brush strokes and moody lighting. Appropriating the title of Monet's work, Leroy dubbed the show *The Exhibition of the Impressionists*. As is so often the case, a word coined in mockery would go on to become the established term for a new art movement.*

* FOOTNOTE Leroy brought the word 'impressionist' to the fore, but he wasn't the first to deploy the term. The painters Daubigny (1817–78) and Manet (1832–83) had previously used the word to describe their own works.

Live with it a while and Monet's sunrise can't fail to seduce. Somehow, despite the fuzzy boaters and unlikely colours, it feels more real than a detailed landscape. Monet has captured the essence of a sunrise over water – what the eye might see before the brain tells it what to see. This is the crux of Impressionism. Such works show us what is both before the artist, and within. Impressionist paintings take a fleeting moment and wrap it in light and mood and emotion.

The Impressionists divided people for many years. Some welcomed the bold new direction, but others found the leap too radical. You don't have to search long through contemporary accounts to find scathing comments, as people struggled to come to terms with this new direction. Phrases like 'intolerable monstrosities', 'ridiculous and horrible', and 'victims of an unlucky disease' jump out. I'm particularly amused by the *Daily Chronicle's* anonymous reviewer of July 1883, who comments on an Impressionist exhibition in London. The dancers of Degas are described as 'really hideous red-headed ballet girls with figures ill-drawn, ill-placed and ill-proportioned'. Proto-impressionist Manet, meanwhile, had contributed '… a study of some of the ugliest Spaniards of both sexes we have ever seen' (*Le Ballet Espagnol*, 1862). The reviewer concludes by hoping to have seen 'the first and last of such pictorial art in this country'. He would be magnificently disappointed.

Few would now side with those reviewers. The best impressionist paintings are not only respected and much-loved works of art, they might even be considered among the finest achievements of our species. There are many reasons why these canvases speak to us so strongly, but part of that magic formula stems from the conditions in which they were created. Impressionists tended to work outdoors, metaphorically soaking up the atmosphere then decanting it onto the canvas. They were famous for it. There are exceptions (notably Degas), but to a close approximation, Impressionism was an outdoor pursuit.

Because of the popularity the Impressionists later achieved, we sometimes view their work as the first great wave of outdoor painting, when artists abandoned their traditional studios for more sylvan workspaces. There

were, though, several notable precedents. The most significant is the group
of painters who came to be known as the Barbizon school, after the town
in north-central France in which they were based. These painters – who
include Théodore Rousseau (1812–67), Jean-François Millet (1814–75)

and Charles-François Daubigny (1817–78) – immediately preceded the Impressionists, active during the middle of the 19th century. This was a group of friends who loved to get out into the countryside to paint. Barbizon was ideal, surrounded by almost 17,000ha (42,000 acres) of the pristine Fontainebleau Forest, yet just a short journey from Paris. During the summer months, the artists would spend long days painting among the trees, gullies, rocks and fields, before regrouping in the evening for a good natter about what they had discovered.

It sounds like a harmless, even frivolous pursuit today, but to paint freely from nature was then radical. Serious painters worked in studios. Professional artists sought more worthy subjects. Of course, landscape painting was nothing new; artists have always been inspired by the trees and fields around them. But until the 19th century, outdoor scenes were usually painted to the conservative rulebook of salons. To get a landscape exhibited, it had to respect long-held traditions of composition and setting. You could paint the hills and valleys, by all means, but only as an idealized backdrop to more immediate events going on in the foreground – posh people enjoying a picnic, for example, or a scene from ancient myth. It was all a bit stifling.

In the first decades of the 19th century, painters such as John Constable (1776–1837) and JMW Turner (1775–1851) in England, and Thomas Cole (1801–48) in America, began to bring nature to the fore. Now, the crashing waves of a seascape or a crooked, moss-covered gatepost could serve as the central feature in a painting. Even a cloud was fair game. Such works were rarely painted entirely outdoors. Usually, the artist would make a preparatory sketch in the wild, then do most of the tricky work back in the studio. This was the method favoured by Camille Corot (1796–1875), a towering figure of French landscape painting. He too painted in the Fontainebleau Forest, but tended to smarten up his canvases afterwards, to better appeal to the salon crowd. This is why the nature-loving members of the Barbizon school stand out. They were among the first to advocate painting truly *en plein air* – totally outdoors and faithful to the scene.

Why had it taken so long? Painting outdoors has many perils. Sudden showers or gusts of wind can damage a canvas or equipment. The shifting

clouds and lighting conditions don't do the artist any favours either, especially if the painting requires several days. A drying canvas is rarely enhanced by a rogue bird dropping or a curious swarm of midges. And there's the obvious practical problem of carrying the kit around. The canvas and easel are trouble enough, but how do you transport the various powder pigments, oils and mixing vessels without some kind of wagon? None of these problems was insurmountable, but they combined to make painting *en plein air* a bit of a hassle.

The barriers tumbled in 1841 with the invention of the paint tube. John Goffe Rand (1801–73) was himself a portrait painter, born in the USA but working in London when he first tested the squeezable tin tube. Before his invention, artists typically made up their paints by mixing pigments and oil, and storing any surplus in watertight animal bladders. Needless to say, this was not an activity for those who despise clutter. An artist could quickly become surrounded by paraphernalia – trouble enough in the studio, but a messy hindrance to outdoor painting. The tube changed everything. Oil and pigment came ready-mixed in a portable container, which could be resealed after use without recourse to the butcher. Portable box easels with telescopic legs, and compartments for painting tools, made their debut around the same time. Suddenly, the whole world was a potential studio. Renoir famously observed that 'Without tubes of paint, there would have been no Impressionism.'

The Barbizon artists had pre-empted all this, making their first *plein air* paintings before the paint tube became widely available. But its invention made things much simpler, and lowered the barrier for other painters to join them in the forest. Among their number were the young Monet, Renoir, Sisley and Bazille (1841–70) who all visited Barbizon while studying in Paris. They learnt the value of quick, spontaneous brush strokes, drawn from nature and not reliant on an academic back catalogue of approved motifs. The techniques they developed in the forest of Fontainebleau were important steps on the road to Impressionism.

Van Gogh only sliced off part of his ear

It's the one thing everybody knows about art: Vincent van Gogh (1853–90) sliced off part of his own ear during a fit of mental anguish. And it's true. The mutilation is well documented in records from the time, the testimony of those who knew him, and even the artist's own work (*Self-Portrait with Bandaged Ear* is one of van Gogh's most famous pieces). The mutilation is thought to have happened on 23 December 1888 during one of the painter's darkest moments. Research by amateur sleuth Bernadette Murphy* recently overturned a long-held consensus about the injury. It now seems that van Gogh removed almost his entire ear, rather than just the lobe.

The clinching evidence is a long-lost letter from Felix Rey, a doctor who had treated van Gogh's wound while serving as a young intern. Rey had sketched the disfigurement from memory in the 1930s while helping Irving Stone research his fictionalized biography *Lust for Life* (later made into a film with Kirk Douglas in the lead role). The brief missive includes two diagrams, one showing the direction of the incision through van Gogh's ear, and the other depicting the unenviable result. Both indicate that the ear was completely severed, save for a minute section of lobe.

The discovery overturns decades of art history, which had long supposed the wound to be more superficial. Although it relies upon a 50-year-old memory, the evidence has been accepted by no less an authority than the Van Gogh Museum in Amsterdam, and given further credibility by a BBC documentary. We can now say, pretty definitively, that the unfortunate painter's self harming was more extreme than previously believed.

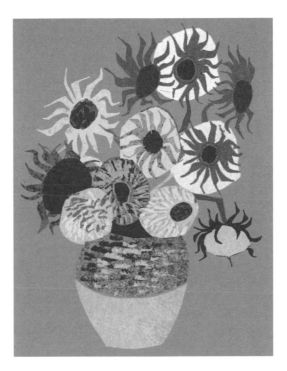

Murphy was also able to fill in other details of this turbulent episode in the painter's life. It had always been believed that van Gogh wrapped his ear in cloth before presenting it to a local prostitute named Rachel. According to Murphy, who claims to be the first to trace the girl's family, 'Rachel' was instead a maidservant called Gabrielle, who had herself suffered from a serious dog bite.

With the endorsement of experts, it appears to be case closed on this particular mystery of van Gogh's ear. But the painter's life still holds plenty of further scope for conspiracy theorists as well as serious research.

* FOOTNOTE Murphy has written up her investigation in the book *Van Gogh's Ear: The True Story*, Chatto & Windus, 2016.

A long-standing rumour insists that the ear was accidentally sliced off by van Gogh's friend and fellow painter Paul Gauguin (1848–1903), who flourished his sword a little too fervently during an argument. The pair later invented the self-harming story to protect Gauguin's reputation. Intriguing circumstantial evidence props up this version of events, and some believe there are many veiled allusions to the incident in the later correspondence of the pair. Yet no smoking gun has ever emerged to raise the claim above the level of speculation.

Speaking of smoking guns, the artist's death by bullet has sparked still further intrigue. The widely held belief is that van Gogh died in his bedroom on 29 July 1890, two days after suffering a self-inflicted gunshot wound to the chest while painting in a wheat field. The artist lingered long enough to tell several people that he'd pulled the trigger on himself in a suicide attempt. Nobody witnessed the shooting, leaving plenty of room for latter-day conjecture.

One alternative scenario was played out in the 2011 biography *Van Gogh: The Life*, by Steven Naifeh and Gregory White Smith. The duo argue that van Gogh was unlikely to have attempted suicide; his most recent paintings were upbeat, and he'd said in correspondence that suicide was sinful. Other points did not add up. Van Gogh must have walked about a mile with a bullet in his chest, if he had indeed been painting in the field he described. Further, his easel and paints were never found at the scene. The authors instead favour a scenario in which the artist was accidentally shot by drunken youths with a malfunctioning gun. There is some supporting evidence for this idea, but nothing strong enough to definitively overturn the conventional view of van Gogh's death.

Kandinsky invented Abstract art

Does anyone ever have an original idea? Any fresh approach must get its inspiration from somewhere. Even the people we regard as pioneers were influenced by the work of those who came before. Quite often, the person we consider as an 'inventor' was not the sole pioneer, only the most successful.

Take Wassily Kandinsky (1866–1944). The Russian painter is widely regarded as the founder of Abstract art. This movement, in its purest form, did away with anything from the real world. Gone were humans; flown the cherubs. This was an art with no buildings, no bountiful fields or brooding skies. No bowls of fruit. The abstract realm is one of shapes, colours, lines and gestures. It was a bold new direction*, and one that led to some of the greatest art of the 20th century.

Kandinsky made his earliest abstract painting (untitled) in 1910 – a busy watercolour of dark-toned swirls and curves. It is hard to describe. The

* FOOTNOTE 'Hang on, hang on,' you might be thinking. 'Surely people did this before. I mean, what about all those lovely patterns in medieval manuscripts or Islamic architecture? They don't represent anything in the real world either.' You'd be right, of course. As we saw in the opening chapters, non-representational art is probably the oldest form of art. When we talk about Kandinsky as a pioneer, we mean that he initiated the *artistic movement* that came to be known as Abstract art. He took abstraction beyond the world of mere decoration, and put it onto the walls of art galleries (and not as wallpaper).

shapes seem random and unfamiliar; they do not *represent* anything. Others were dabbling in these waters at the same time. Piet Mondrian (1872–1944) and Kazimir Malevich (1878–1935), for example, had already introduced a degree of abstraction into their paintings. But Kandinsky was ahead of the field in banishing anything we might point at and say 'Ah, look, a thing'. Instead, he compared his paintings to music, with rhythms and harmonies that were beautiful in their own right, without the need to look like stuff.

Kandinsky was, for a long time, the undisputed pioneer of Abstract art. In recent years, however, a little-known Swedish artist called Hilma af Klint (1862–1944) has been nibbling away at his priority. Af Klint was an academically trained artist, but also a passionate mystic. Much of her work has a strong spiritual element. In 1905, an inner voice urged her to proclaim a new philosophy of life. She did so through the medium she knew best: painting. Her mystical commission – a series of paintings known as *Primordial Chaos* – was fulfilled over the next two years. The works present a riot of swirls, spirals and circles that, more often than not, are entirely abstract. It's impressive stuff, and pre-dates Kandinsky by up to half a decade.

All this remained obscure until recent years. Partly, this was af Klint's own doing. Although she exhibited her more traditional paintings, the abstract pieces were never allowed out in public. Indeed, her will stipulated that they should remain hidden until 20 years after her death, when she felt the world would be ready to understand their significance*. Her work has also been dismissed in some quarters because of its associations with spiritualism, as though her beliefs somehow diminish her significance. Regular exhibitions since the 1980s have now ensured Hilma af Klint a secure place in the story of modern art, but she still lacks the fame of Wassily Kandinsky.

But the origins of Abstract painting can be pushed still further back, and to another spiritualist artist. To say that the works of Georgiana Houghton (1818–84) were way ahead of their time is an understatement. Her remarkable drawings look like someone's gone to war with a spirograph. Intricate curves and loops tangle in a cat's cradle of colour. All this while Kandinsky was still in diapers. Houghton claimed that her unique art was drawn under the guidance of spirits, including such illustrious spooks as Titian and Correggio. In 1871, she exhibited 155 of her spirit paintings on Old Bond Street in London. In the uptight, mid-Victorian world, where classical revival paintings were the hot fashion, Houghton's abstract swirls were a baffling aberration. The press gave her a mauling. 'Very sorry scrabbles,' thought one reviewer in *The Examiner*, warning his readers that the exhibition would '... disgust all sober people with the follies it is intended to advance and promote'. Nobody really got it. Houghton and her watercolours slipped back into obscurity until very recently, and many of

* FOOTNOTE Some of Klint's paintings are crying out for the attentions of conspiracy theorists. The spirals of her *Seven-Pointed Star* (1908) series, for example, look for all the world like the tracks of charged particles in a bubble chamber – an unimagined technology at the time, which would reach maturity at CERN exactly 20 years after the artist's death. Other paintings resemble the flight paths or parts of space probes. Just coincidence, of course, but if someone's looking to commission a sci-fi reboot of *The Da Vinci Code*, there's definitely plenty of material here.

her paintings are lost. Will she ever be crowned as the world's first Abstract painter? Probably not. As a true one-off, she had no known influence on the Abstract movement of the 20th century, and so sits outside the tradition established by Kandinsky.

Other famous artists sometimes get more credit than they're due when it comes to inventing new styles of art …

Dalí and Surrealism Salvador Dalí (1904–89) is to Surrealism what a penguin is to a fruit bowl. Put in more rational terms, he's the one Surrealist painter that anyone can name. His melting clocks and lobster telephone are cultural icons. But he wasn't the first to let his subconscious percolate onto the canvas. Some point the finger all the way back to Hieronymus Bosch (c.1450–1516), whose religious panel paintings are filled with peculiar, nightmarish figures.

The movement proper started in the early 1920s, influenced by the Dadaists and the work of Sigmund Freud (1856–1939). Its foundation is usually credited to André Breton (1896–1966), though there were rival claimants. The Frenchman set out his stall with the 1924 *Surrealist Manifesto*, which defined Surrealism as not just an art form but applicable to all facets of life. The manifesto provides an easily quotable date for the origins of Surrealism, but the movement's genesis is murkier than often portrayed. The term was first coined by playwright Guillaume Apollinaire (1880–1918) as far back as 1917, and earlier works such as Giorgio de Chirico's (1888–1978) *The Song of Love* (1914) are clearly in the Surrealist spirit. Dalí was a relative latecomer, joining the Surrealist group only in 1929. His masterpiece *The Persistence of Memory* followed in 1931.

Picasso and Cubism Cubist painting attempts to depict an object from various angles simultaneously. A sitter's face, let's say, might be shown front on, in profile, and from below, all at the same time. The first stirrings of this technique can be seen in the works of Cézanne (1839–1906), whose famous still lifes play fast and loose with perspective. But Cubism is most intimately associated with Pablo Picasso (1881–1973), who created his first works in the style in the 1900s. He was certainly a key player, but his friend and colleague Georges Braques (1882–1963) deserves at least equal credit,

for it was his work that gave rise to the term 'Cubism'. His 1908 painting *Houses at l'Estaque*, inspired by Cézanne, shows a series of dwellings without any intelligible perspective. Art critic Louis Vauxcelles described Braque as 'reducing everything, places and figures and houses, to geometric schemas, to cubes'. Yet again, the name of a new artistic movement was coined by a sceptical reviewer.

Warhol and Pop Art: Few people who pay attention to the art world would make the mistake, but it's not unreasonable to suppose that Andy Warhol (1928–87) invented Pop Art. His key works – repetitive Marilyns, Campbell's soup tins, gunslinger Elvis – enjoy a level of fame that surpasses anything else in the genre. He got his first solo show in 1962. But the origins of Pop Art, both as a term and a movement go back to at least the mid-1950s, when British artists such as Richard Hamilton (1922–2011) and Eduardo Paolozzi (1924–2005) were experimenting with collages made from mass-produced images. Pop Art would find its glory days in 1960s America, with Warhol forever cemented as its figurehead.

Pollock and Abstract Expressionism: Picture a painting by Jackson Pollock (1912–56). Colourful dribbles swirl across an elongated canvas. There is no single focus. No trees, people, buildings or objects are depicted. So the first half of the term is easy to understand. This is an Abstract painting. The composition might look pretty random, but Pollock wasn't dropping his paint willy-nilly. His motions across the canvas are at least partly deliberate. He's following his urges and inner feelings. He's expressing. And hence we get Abstract Expressionism.

Pollock's drip paintings are probably the best known works of Abstract Expressionism, but the movement is exceptionally varied. Perhaps the next most famous artist here is Mark Rothko (1903–70). Where Pollock covered his canvases with a controlled chaos of paint, Rothko's leitmotif was to partner up oblongs of colour. They are designed to stir emotions, as subjects for meditation and contemplation.

Neither Pollock nor Rothko were the first to explore this territory. The term 'Abstract Expressionism' had been ventured for a number of related movements in Europe as early as 1919. Works by Wassily Kandinsky from

the 1920s, for example, are sometimes considered to belong to this genre. As a movement, though, Abstract Expressionism would not get going until the 1940s, and in New York. The term was first used in this context in 1946, by art critic Robert Coates. At that time, a number of American artists had been playing around with the techniques that would come to characterise Abstract Expressionism. Arshile Gorky (1904–48), for example, brought a sense of spontaneity to his abstract paintings. Hyman Bloom (1913–2009), meanwhile, was acknowledged by Willem de Kooning (1904–97) and Pollock as 'the first Abstract Expressionist in America'. In truth, the origins of Abstract Expressionism are murky, in the sense that it sprang up from many influences, prefigured by numerous artists. Pollock took things in a radical new direction with his drip paintings, but no art is created in a vacuum.

Painting is dead – nobody does it anymore

Hollywood is often accused of rewriting history; revising the facts to better suit an action-adventure film. The 19th century finds its equivalent in the brushwork of Paul Delaroche (1797–1856). The French painter was renowned for his striking canvases showing important events from history, even if they weren't always entirely accurate.

Take his magnificent 1833 canvas showing the execution of Lady Jane Grey. In his painting, the blindfolded queen fumbles her way towards the chopping block, helped on by a sympathetic nobleman. Norman columns and arches form a dimly lit background suggestive of a dungeon. In fact, the nine-day queen was executed in the open air on Tower Green – where Anne Boleyn had met the same fate a few years before. The spot was surrounded by Tudor architecture rather than the 11th-century buildings we see in the painting. Still, it's a smashing piece. The monumental stone may be inaccurate, but it reinforces by contrast how helpless and pitiable is this poor teenage Grey, caught unwittingly and literally in the cut and thrust of Tudor power play. Delaroche painted another dubious window on history when he imagined Oliver Cromwell peering into the coffin of Charles I, recently executed on Cromwell's orders. It *could* have happened, but there is no contemporary source.

Six years after painting Jane Grey, Paul Delaroche saw his first photograph (or, more accurately, daguerreotype). 'From today, painting is dead,' he supposedly declared. What need would there be for the time-consuming, error-prone act of painting, when one could capture a truthful likeness in seconds? Hereafter, queens and usurpers would appear in their correct settings. Artistic licence was banished by the lens.

Delaroche's comment in 1839 came just before what is arguably the most important century in the history of painting. The next decades brought such giants as Cézanne (1839–1906), Degas (1834–1917), van Gogh (1853–90), Monet (1840–1926) and Picasso (1881–1973), whom most would rank among the greatest artists of all time. Of the 30 most expensive paintings ever sold, 28 were painted after the advent of photography. Far from bringing an end to painting, photography coincided with the dawn of a golden age – a topic we'll explore in greater detail in a later chapter.

Other media came along in the 20th century to further challenge the supremacy of painting. The rise of conceptual art, for example, brought everyday objects, and even intangible ideas, into the creative firmament. Why bother with paintbrushes when you could defecate into a bucket and call it art? And yet painting morphed once again to embrace new styles – from Abstract Expressionism to Pop Art. Household names such as Pollock (1912–56), Warhol (1928–87), Rothko (1903–70), O'Keeffe (1887–1986), Hockney (born 1937) and Bacon (1909–92) all came along after the watershed moment of Duchamp's (1887–1968) urinal, and all worked primarily with paint. It's the medium that refuses to die; *Friday the 13th's* Jason Vorhees in the guise of creative expression.

It's arguable that painting isn't as big a deal as it once was. New forms of art that encompass found objects, installations, video, performance, viewer interaction and modern technologies take up increasing amounts of space in the contemporary art gallery, to the point where painting is often on the sidelines. Nor do most art schools teach painting to anything like the levels they once did. But there is something inherently human, almost biological, about daubing liquids onto a surface. Painting will always be with us in some form. It would be wrong to write it off once again.

There are many famous painters still working today. David Hockney, despite a recent switch to digital art, still wields the paint brush. Bridget Riley (born 1931), though famed for her clinical Op Art geometries, works mainly in paint. Maggi Hambling (born 1945), Anselm Kiefer (born 1945), Vija Celmins (born 1938), Marlene Dumas (born 1953), Peter Doig (born 1959), Gerhard Richter (born 1932) ... the list could fill a chapter.

Meanwhile, admiration of great paintings is unabated – the unrelenting crowds at the Louvre, National Gallery and the Met speak for themselves.

It might be ventured that the current crop of painters are less inventive than previous generations. Each has his or her unique styles and motifs, but none has taken art in a major new direction like Pollock or Warhol, Giotto (1266–1337) or Caravaggio (1571–1610). Painting today travels through familiar territory, mixing together old styles in new ways, but rarely finding a truly new direction. That said, there is always some innovation. The rise of street art, for example, might be viewed as a continuation of the history of painting, albeit on bricks and concrete rather than paper or canvas. Just when we think there is nothing new to be said with paint, someone will find a way to create three-dimensional paintings you can walk through, or combine paint with aroma or sound to produce something fresh. Maybe we'll see the rise of robot artists. Who knows? Whatever else the future might hold, it will probably grip a paint brush.

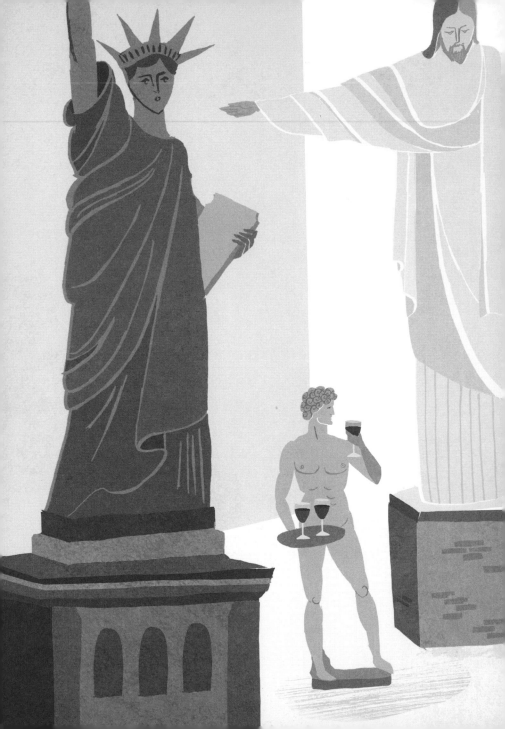

Sculpture

From the surprisingly colourful statues
of the ancient world to the landmark
sculptures of today.

Ancient
sculptures
are plain
and boring

It's 400BCE and you are climbing the steep steps of the Parthenon in Athens to pay your respects to the goddess Athena. Your neck is sore from craning for a view of the marvellous building above you on the Acropolis. You reach the summit and, moving closer, the temple finally reveals itself. You can only continue to gaze upwards. Its vast pediment, way above your head, is crowded with gods, heroes and horses, painted in rich colour.

Having reached the temple, you pass through a double colonnade, whose strength and scale are like nothing you have ever witnessed. Above the columns, episodes from mythology are retold in marble. Each shaft of sunlight that passes between the columns reveals a rainbow of reds, yellows and blues.

And then you reach the central chamber, or *cella*, which you are forbidden to enter. A priest approaches. He will mediate between you and the goddess. You hand him your offering. He nods, and turns to face Athena. The deity towers behind him. The scale bewilders. She stands over 12m (39ft) tall, so dwarfing the priest that it would be easy to imagine her scooping him up, like the winged goddess Nike she holds in her right hand. If her richly decorated shield were to topple, the priest would be crushed. It is only now that you notice her eyes. A piercing blue, they see everything at once. These azure orbs protrude from a milky face of ivory with fulsome red lips. She is alive; she must be.

Athena is illuminated only by oil lamps and the light from the doorway, yet still she dazzles. Her flowing robes, headdress, hair and sandals are covered in gold leaf, as is the menacing serpent erect at her feet. A thousand jewels sparkle from her upper torso. You are granted only a brief sight of the goddess, but it is a vision you will never forget.

Sadly, the great statue of Athena is long lost. Created around 447BCE, by the renowned sculptor Phidias (c.480–c.430BCE), she was the grandest statue of her day. She was also a world away from our modern notions of what a classical sculpture should be. Go to any big western museum of antiquities and you're bound to bump into a selection of marbles from Greece or Rome. The ancients were fond of memorializing their gods, muses, generals and emperors. What survives today is all very beautiful, but it is also a bit, well, monochrome.

You'd be forgiven for thinking these sculptures were created that way – pearly white with unseeing eyes*. Indeed, when Renaissance sculptors like Michelangelo (1475–1564) began to study these ancient works, they had little idea just how colourful the originals had once been. Most Renaissance sculptures (and most that followed) are left as plain stone, in a misguided imitation of antiquity.

Surprising as it might seem, ancient statues were often created in lifelike colours, with glass beads for eyes. Over the centuries, the paint has worn away. The gold would have been melted down for coins, and the bronze for weapons, while any glass has been crushed. This leaves only milky marble to endure the centuries. It is all that survives, so it is all we see.

Greek sculpture, in particular, was often brightly coloured to a degree that might look gaudy or tacky to modern eyes. The statue of Athena was particularly rich. Her golden robes are thought to have weighed as much as a tonne, while her flesh required lavish quantities of ivory**. She was built around a wooden frame rather than the more familiar marble. Other statues may not have been so lavish, but most would have been painted or bejewelled to some degree.

* FOOTNOTE One tongue-in-cheek conspiracy theory would have us believe that the ancients made no statues at all. The white marble forms that fill our museums are actually the victims of Medusa, whose gaze could turn people to stone.

** FOOTNOTE Here's your fancy word for the day: chryselephantine. It describes a form of statue, such as Athena, that is resplendent in gold and ivory. The style was widespread in the ancient world. The gold could be readily removed if the city needed to mint coins. Athena, then, was a kind of sacred treasury – part object of worship and part gold store. Imagine the Bank of England erecting a vast statue of Jesus by melting down its bullion holdings. The statue of Zeus at Olympia – one of the Ancient Wonders of the World, also created by Phidias – was another example of chryselephantine sculpture, though no copies have survived the ages, and its exact form and scale are uncertain.

In recent years, new technology has literally shed new light on the faded colours of ancient statues. UV spectroscopy reveals the minute specks of organic compound that remain on the surfaces. Different compounds reflect the UV in different ways, so individual pigments can be established. We can now piece together with some certainty the different hues and combinations that once enriched these millennia-old artefacts. Yet the popular image of an ancient Greek or Roman sculpture will no doubt always remain one of white marble.

Athena's fate is uncertain. Her importance diminished with the rise of Roman Empire, particularly when the coming of Christianity put paid to the false idols of ancient veneration. There is some evidence that she was taken to Constantinople in the 5th century CE, but the trail is cold. We know what she looked like from Roman copies, but these are small and plain and give no sense of the majesty of the original.

There is, however, one place you can get a flicker of Athenian awe. It's not in Greece, or even Europe, but Nashville, Tennessee – more famous for 'The King' Elvis Presley than the goddess Athena. Here, in 1897, a full-scale replica of the Parthenon – albeit initially made from brick, wood and plaster, and later remodelled in concrete – was built as a centrepiece of an exposition. It stood empty for decades until sculptor Alan LeQuire (born 1955) created a convincing replica of Athena Parthenos to go inside. His sculpture, unveiled in 1990, is of similar proportions to the original and is thought to be the largest indoor sculpture in the world. Ancient Athenians would baulk at his choice of materials, however: steel, aluminium, concrete and fibreglass. The statue has since been gilded, though with only a fraction of the gold borne by the original. Still, it remains an impressive sight, and a far cry from the pale marbles that fill our museums.

It would also be wrong to assume that all ancient sculpture was made of marble. The Greeks and Romans also created great works in metal and wood, but much has been lost. Bronze sculptures were probably more common than stone statues but, as we've seen, the metal was often melted down for reuse. Nevertheless, several examples have survived from antiquity, such as the magnificent statue of Marcus Aurelius in the Capitoline museums, Rome. Wood was less commonly used for fine arts, and is even rarer in its survival to modern times, but examples are known.

The Statue of Liberty is the largest sculpture in the world

Like the pyramids, Big Ben, Sydney Opera House and the Eiffel Tower, the Statue of Liberty is an emblem of her nation. Many a film has included Lady Liberty in an establishing shot: her towering form is a visual shorthand for New York City, and the wider USA. She is, unquestionably, the most famous statue in the world.

It would be easy to believe that she is also the most monumental statue in the world. After all, the copper goddess rises 93m (305ft) above New York Harbor. The statue itself, minus the base, is a whopping 46m (151ft) tall from the tip of the torch to the soles of her feet. If she lowered her arm, she'd still stand 34m tall (111½ft), making her 25 times

larger than the average French woman*. Her nearest rival in the popular, Western imagination – Christ the Redeemer in Rio – stands a mere 30m (98½ft) tall. The long-lost Colossus of Rhodes, an Ancient Wonder of the World, was of similar height.

Despite her enormous fame – and frame – Liberty is not the world's biggest statue. That title belongs to the Spring Temple Buddha in Henan Province, China. This depiction of the Vairocana Buddha was completed in 2008. At 128m (420ft) tall, it is some three times loftier than Liberty. Its big toe alone is taller than the typical visitor. In second place is the 116m (380½ft) Laykyun Sekkya Buddha in Myanmar.

Asia contains many further statues of formidable height. Most depict the Buddha or another religious figure, but the list also includes generals and emperors. Russia contains an 87m (285ft) figurative sculpture called *The Motherland Calls*, which commemorates the Battle of Stalingrad. The Statue of Liberty isn't even the tallest statue in the Americas. It is trumped by a 50m (164ft) statue of a Chimalli Warrior in Chimalhuacán, Mexico, and a 46.7m (153ft) statue of the Virgin Mary in Trujillo, Venezuela. All in all, the tiny Statue of Liberty doesn't even scrape into the top 40 tallest statues in the world.

All of these structures are dwarfed, however, by a little-known colossus in the north-east of England. Northumberlandia, the 'Lady of the North' is a reclining sculpture made of 1.5 million tonnes of rock, clay and soil. She is said to be the largest sculpture of the female form anywhere in the world. Were she to stand up, the earthy giant would reach 400m (1,312ft – almost a quarter of a mile) high putting her on par with the Empire State Building. The Statue of Liberty is a mere babe in arms by comparison.

* FOOTNOTE Although she's become a symbol of America, Lady Liberty was designed and constructed in France, and gifted to the USA. Her unveiling in 1886 received mixed reviews. While many were impressed by her scale and form, the art critic of *The Times* damned with faint praise by declaring her 'not wholly vulgar'.

Equestrian statues contain a hidden code showing how the subject died

Equestrian statues come in three basic designs: the horse will have all four hooves on the floor, or one forehoof raised, or both the front hooves raised higher as though the horse is rearing up. According to popular lore, you can learn something about the rider by observing which hooves are raised. The firmly planted horse denotes a rider who died in old age. The rearing horse indicates a soldier who died in battle. The middle case, where just one hoof is airborne, suggests that the rider was badly injured but did not actually die on the battlefield*.

Like many 'secret codes', it turns out to be a 'secret fib'. There is no consensus whatsoever to determine how a subject's horse will be sculpted. It's all down to the whim of the artist or client. A few famous examples will quickly debunk the code.

A dashing statue of the seventh US President Andrew Jackson enlivens Lafayette Square, Washington D.C., and is said to be the first equestrian statue cast in America. The general and statesman rides a rearing horse, suggesting he died in battle, when in reality he died at home in old age. Another memorial in Kansas City, Missouri has him riding a fully grounded horse, more in keeping with the 'secret code'.

A similar disparity can be seen in the memorials to Genghis Khan. His equestrian statue in Mongolia is thought to be the world's tallest horsey statue, at 40m (131ft). The warlord's steed stands proud with all four hooves on the plinth, indicating a death unconnected to battle. The horse on his mausoleum in Ordos, China, meanwhile, holds one hoof in the air. A further monument in Hulunbuir shows the warrior's horse with both front legs raised, indicating he died in battle. Even a man as powerful as Genghis Khan cannot die in three different ways. The confusion reflects vagueness in his biography – Genghis probably died from a battle wound, but nobody knows for sure. Or it could be that the secret code is nonsense.

* FOOTNOTE Three hooves in the air only happens on the Ferrari logo. Four hooves off the ground suggests the subject fell off a Pegasus and was immortalized by a very clever sculptor.

Easter Island contains hundreds of mysterious stone heads

The samosa-shaped Easter Island stands alone in the South Pacific, more than 2,000km (1,243 miles) from any other land. Its culture grew up in near-isolation, and was not glimpsed by Europeans until 1722. Those first explorers found the island guarded by 887 stone figures – giant, imposing sculptures known as *moai* (pronounced 'moh-eye'). The structures are thought to represent important ancestors, and date back to around 1250CE.

The moai are no garden gnomes. The largest stood 10m (32¾ft) high, while the heaviest was 82 tonnes. To put this in the usual context, that's an equivalent weight to six-and-a-half double-decker buses. Imagine shifting that kind of bulk around without the benefit of mechanical aids.* The islanders didn't even have access to metals, and carved the moai with stone tools.

The Easter Island *moai* are among the world's most famous sculptures. The picture you're seeing in your head, though, may not be entirely accurate. The island is remote, and the vast majority of us will never pay a visit. We therefore build up our impressions from popular culture. The sculptures are often portrayed as giant heads, keeping watch over the island. While the heads are disproportionately large, all of the statues also include full bodies. Some are buried up to their chins in volcanic detritus, but dig down and you will find that they are not decapitated. Nor do they point out to sea as guardians of the island. Most look inland. A final misconception is to assume that they're all still standing where the islanders placed them. In

fact, every single statue had been overturned by the mid-19th century. The ones that stand today have been re-erected and restored.

Indigenous islanders still make up much of the population, but their numbers have dwindled from the statue-making heyday. Often, successful but tech-light civilizations crumble after first contact with Western explorers, succumbing to disease or bloodshed. That does not seem to be the case on Easter Island. The population here, known as the Rapa Nui, was devastated by an ecological disaster in the century before first contact. For years it was believed that the islanders had deforested themselves to catastrophe, cutting down trees to build their canoes, dwellings and statues. It's certainly true that the island was once covered in foliage, and today is mostly barren. A rival idea now suggests that the trees were killed off by Polynesian rats, an accidentally introduced species that gnawed away at the roots, eventually toppling the forests.

* FOOTNOTE Predictably, and stupidly, this impressive achievement has often been credited to aliens, as though the Easter Islanders were too simple or weak to build their own landmarks. See also the pyramids, Stonehenge, the Sphinx, Aztec cities, and just about any other antiquated structure you care to name.

Architecture

Though usually more functional than your typical painting or sculpture, architecture is often considered one of the visual arts – an inhabitable sculpture.

There are three classical orders of architecture

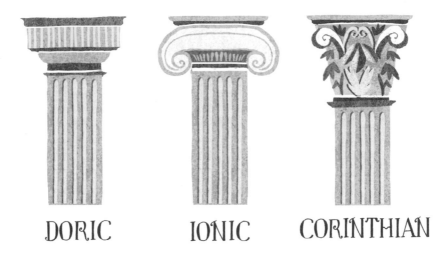

DORIC IONIC CORINTHIAN

Doric, Ionic and Corinthian. If you've spent just a wink of time reading about ancient architecture then you'll have heard about the three classical orders shown in the illustration. The grand public buildings of ancient Greece all conformed to one of these styles, most easily distinguished by the columns at their entrance. Doric, with its plain but strong profile, was most famously used on the Parthenon; Ionic boasts fluted columns and ram-horn capitals; while Corinthian is a more florid affair, surmounted by swirling acanthus leaves.

These three modes of building were revived during the Renaissance and are still with us. Go to any major Western city and you're sure to chance across a Doric, Ionic or Corinthian column before too long.

Slightly less well-known, but still fairly common, are two additional orders developed by the Romans. They introduced the Composite style, which mixes features of Ionic and Corinthian. The Tuscan style, meanwhile, is a kind of simplified Doric, lacking fluting on the columns. They are not mentioned by Vitruvius (c. 70–15BCE), the main architectural source of the era. Rather, they were considered variations on Corinthian and Doric, and not seen as separate orders until the Renaissance. As such, not everyone accepts them as true classical orders.

A common mistake is to assume that the classical orders are only concerned with the capitals at the tops of the columns. This is the bit most people look to, as it's easy to distinguish the ram's horns of Ionic from the leafy capital of Corinthian from the simplicity of Doric. But the term 'order' properly relates to the entire structure. For example, the Tuscan order not only lacks fluting on its columns, it also has a simplified entablature – the various layers supported by the columns.

That said, these rules for building in stone were not always *set* in stone. The ancients introduced significant variation within a particular order. Greek Doric columns, for example, lack any base, whereas their Roman counterparts often included one. It was only later Renaissance writers who got pernickety about dimensions and ornamentation, specifying each order in minute detail. This was also when the term 'order' was first coined.

So, we've swollen the original three orders to include two more: Doric, Ionic, Corinthian, Composite and Tuscan. Any advance on five? Well, yes. Over the centuries, writers and architects have defined additional orders, some of which are simply variations on a theme. The Superposed order, for example, sees different styles of column at different storeys of a building, usually with Doric at the base, Ionic in the middle and Corinthian at the top. The most famous example is in Rome's Colosseum, but a tower at the Bodleian Library in Oxford flaunts all five orders on its façade. The Colossal order, meanwhile, is a 15th-century invention not seen in the ancient world, in which columns span two or more storeys of a building. The style was particularly popular in the decades either side of the turn of the 20th century, when constructions such as Selfridges in London and the James A. Farley building in New York made use of its imposing manner.

Seven orders and counting, but it doesn't quite stop there. While not so formally defined, numerous alternative systems have been tried over the centuries – again, best identified by their capitals and columns. The Persian Empire, for example, had its own way of doing things. Its most distinctive style included capitals with two protruding bull's heads, as seen at Persepolis. Later Islamic artists were also architecturally creative. The elaborately carved Moorish columns of the Alhambra in Granada, Spain, are unlike anything seen in the Greek or Roman tradition. The Byzantine Empire was, in many ways, a continuation of Roman culture, and that is reflected in its early capitals, which include variations on Composite designs. Later on, the Byzantines developed countless novel styles, which often include animal motifs. The Egyptians had distinctive columns topped with palm, lotus or papyrus patterns, centuries before the Greeks developed the classical orders.

Individual architects have attempted to create their own orders, too. Typically, these styles only see the light of day on one or two buildings. Such experiments are sometimes called Nonce orders – 'nonce' meaning something that is invented or built for just one occasion. One of the more successful examples is the Ammonite order devised by George Dance (1741–1825), which incorporates spiral-shaped fossil patterns on the capitals. This found its way onto a handful of structures in south-east England. Several buildings in the USA, meanwhile, bear architectural features resembling corn or tobacco plants. This style has been called the American order, and was developed by Benjamin Latrobe (1764–1820). You can find it in the Capitol building in Washington D.C., leading to the tongue-twister: the Capitol's capital corn-cob capitals. One slightly eccentric 18th-century designer – the memorably named Batty Langley (1696–1751) – even tried to impose a system of orders onto Gothic architecture, with negligible success.

To sum up, while Doric, Ionic and Corinthian orders remain the most common, other classically influenced styles are not unknown. Keep your eyes peeled.

The keystone is the most important stone in an arch

Picture a stone arch. Its constituent blocks gradually lean inwards until they meet a central, wedge-shaped block at the top. This is the keystone. It is the final piece to be inserted into an arch, allowing the structure to stand proud and bear a load. It is said that the keystone is the most important component of an arch and its name reinforces this impression. Without the keystone, the structure would simply collapse under its own weight. This much is true. But the removal of any other block in the arch would also cause it to collapse.

The keystone is usually the most distinctive piece of the arch. It is often the largest block, and may be decorated with eye-catching carvings. As the last piece to be inserted, it is this stone that locks its lithic companions in place. But to deem it the most important part of the arch is like declaring the liver more important than the kidneys, or the engine of a car less disposable than the chassis. Necessity does not come in degrees.

Another common misconception is that arches were invented by the Romans. In fact, much earlier examples are known from several civilizations. One impressive example is the Canaanite Gate in Ashkelon, Israel. This 4m (13ft) high structure was built around 1850BCE, well over a thousand years before the founding of the Roman Republic. The Romans bag all the fame not because they invented the arch, but because they took it to whole new levels. After inheriting the technology from Italy's earlier Etruscan civilization, the Romans went on to build vast viaducts, arches and arch-laden structures like the Colosseum that are still with us to this day.

Nobody built in concrete before the 20th century

Few things shout '20th century' like concrete. In the aftermath of the Second World War, many devastated European cities turned to the material as a fast and inexpensive option for rebuilding. Meanwhile, Modernist styles of architecture swept the globe, creating such iconic structures as Sydney Opera House and the Cathedral of Brasília, plus countless civic buildings and anything from flood defences to power stations and housing estates.

It may define the 20th century like no other building material, but the history of concrete goes back much further than is often appreciated. Concrete is, after all, a reasonably simple material, comprising aggregate and cement. The most famous concrete survival from the ancient world is the dome of the Pantheon in Rome. Completed in 128CE, this remains the largest unreinforced concrete dome in the world. Such is its magnificence that it's often assumed the Romans invented concrete. In fact, simple concretes were used earlier by the ancient Greeks.

Concrete fell out of favour once the Roman Empire wound down, and was all but lost as a building material. It was rediscovered around the 14th century and gradually found more uses. Although several concrete structures survive from the 19th century, it was really only in the 20th that concrete once again took its place as a mainstream building material. Today, most new structures have some concrete component. Even the sleekest of skyscrapers, seemingly formed from glass and steel, have sturdy concrete floors. And on that note ...

Modern architecture is all just monotonous glass and steel

Walk around any big city these days and it can all look a bit samey. Steel-frame buildings reach for the skies, garbed in curtain walls of glass, with a hint of concrete here and there. There might be the occasional brick, if you're lucky. But mostly glass and steel.

It all makes sense. Building this way is quicker, cheaper and more energy efficient than stone or brick. A glass curtain wall is also a sure-fire way of letting in plenty of daylight, to the benefit of those working inside. To those outside, though, it can all get a bit monotonous. Words like 'soulless' and 'identikit' get bandied around. When entire districts are made this way, town centres really can seem characterless. Where is the charm in endless walls of glass?

I do like to look at this from a wider perspective. Imagine a medieval carpenter, suddenly plonked down in the 21st-century version of his city. He would be dumbfounded. Even the most humdrum office block would astound our time-travelling craftsman. Such large and uniform sheets of glass would drop his jaw as surely as a statue made from diamond. The great heights possible with steel-framed construction and modern engineering would only be comparable to the greatest cathedrals of his own age; but our towers can get markedly taller, and are much more numerous. It's easy to deride the modern office block, but seen from an historical standpoint, every one is a minor miracle.

It's not just the office architecture of city centres that winds people up. There are many who decry the modern apartment block. These too are often built to tried-and-tested designs, with jutting balconies and a preponderance of glass. Developers and architects often work internationally, so similar buildings can be found in cities all across the world. There are many good reasons for disliking such blocks. They might change the character of an area, and are often priced beyond the pay packets of the majority. But I think the charge that modern apartment blocks are monotonous and 'identikit' is a little unfair. Residential buildings have always been built to the pattern of their times. The endless Victorian terraces of 19th-century Britain all look pretty similar to one another, as do the countless clapboard houses in the suburbs of North America. If anything, modern apartment blocks are a more varied form of residential architecture than their

predecessors. While most share common motifs and materials, there are huge differences in shape, size and colours across developments.

It would also be a simplification to assume that all modern buildings are erected from the same building blocks. Yes, more often than not, you'll find large panes of glass decorating a steel frame with a concrete core, but that is not the only way to build. Architects are increasingly incorporating novel materials, such as polymers and plastics, to make their buildings more energy efficient or simply to provide a striking appearance. New buildings are often blessed with green roofs or walls, bringing elements of nature into architecture. Old shipping containers have been upcycled into homes, offices, studios and even shopping malls.

Then there are the true one-offs, unimaginable to our medieval carpenter. Across the world, examples can be found of buildings made from used tyres, plastic bottles and even corn cobs. Thousands flock to the Scandinavian ice hotels, carved afresh from each winter's snow. Whole buildings have emerged from 3D printers – a technique sure to play an important role in future construction. Far from being monotonous, homogeneous places, the cities of tomorrow are likely to be strikingly varied in their architecture. Of course, people will moan about this, too.

There's even talk of building skyscrapers out of wood, or rather cross-laminated timber. Engineered wood is still a new technology, but has the potential to be as strong and fireproof as concrete, and more friendly to the environment. At the time of writing, the world's tallest wooden buildings stand just ten storeys high, but that might change in coming years, with plans for several wooden towers on the cards. Perhaps our medieval carpenter would not feel quite so out of place after all.

Stonehenge was built by druids (and other landmark lies)

It's one of the most famous structures in the world, yet we know so little about Stonehenge. Nobody can say precisely how long the circle has stood there. Still less is known about its original purpose, and how this might have evolved over time. Historians have made educated guesses, but very little about the enigmatic stones is fully understood. One thing we can say, with supreme cocksure certainty, is that this ancient ring of stones had nothing whatsoever to do with druids – at least not when it was first built. The earliest incarnation of the henge is thought to date back to at least

3000BCE, while the great standing stones were put in place by Bronze Age Britons some time around 2500BCE. There is wiggle room in these dates, but multiple lines of evidence put them in this ballpark. The Druids, meanwhile, didn't arrive on the scene until after the coming of the Celtic people around 500BCE. These newcomers would have found the stones already ancient. The gap of centuries is as large as that between our own era and the Roman Empire. The Druids no doubt made use of Stonehenge, but they certainly didn't build it.

The misconception began in the 17th and 18th centuries, when scholars such as John Aubrey (1626–97) and William Stukeley (1687–1765) declared Stonehenge a Druidic relic without really knowing what they were talking about. More scientific analysis has now firmly established that the stones must be much older. Still, it's got to be a more reasonable mistake than claiming aliens built the stone circle, which has (of course) been suggested. The association with the Druids has been reinforced in recent decades with the rise of modern paganism. The stones are now a major draw for New Age believers when access is granted each winter and summer solstice.

Stonehenge is, of course, not the only major landmark that is subject to myth and misconception. Here are a few other favourites from around the world.

Great Wall of China In 2012 an archaeological survey put the length of the Great Wall at 21,196km (13,171 miles) more than twice as long as previously thought. The wall is not a single, twisting line but a complex collection of structures that includes side-branches and loops. The barrier is often touted as the only artificial object visible from the moon. In reality, the disc of the Earth is so small from the lunar surface that the only features to be made out are continents. It's debatable whether the wall can even be seen from low-Earth orbit. Some astronauts claim to have seen it, while others have searched in vain. Meanwhile, other man-made structures such as major highways, dams and artificial islands can be discerned from the edge of space.

Big Ben It's often claimed that the famous London clock is really called St Stephen's Tower, and that Big Ben is the bell: this is all kinds of wrong. The

edifice was officially the Clock Tower until 2012, when it was changed to the Elizabeth Tower in commemoration of that queen's Diamond Jubilee. St Stephen's is another tower elsewhere in the complex. And Big Ben is not the bell, but the largest of five bells – and itself only a nickname.

Eiffel Tower Contrary to expectations, Gustave Eiffel (1832–1923) did not design the tower in Paris that bears his name. That accolade belongs to three of his employees: Maurice Koechlin (1856–1946), Émile Nouguier (1840–97) and Stephen Sauvestre (1847–1919). Eiffel bought the right to the patent taken out by this trio, then had the drive to see it built. The Frenchman got his fingers dirtier with the Statue of Liberty – he personally designed much of the interior support structure.

Pyramids of Giza No buildings have attracted quite so much nonsense as these three Egyptian giants. The complexes were built around the same time

as the present form of Stonehenge, roughly 2500BCE. The Great Pyramid originally rose 146m (479ft), making it the tallest building in the world for almost 4,000 years.

The pyramids are so impressive that many unlikely theories have been put forward to account for their construction. Some claim the structures predate the pharaohs, and that they were instead built by a lost civilization. The people of Atlantis are always a reliable bet. The three pyramids, it's said, resemble the stars of Orion's belt, and the ancients were attempting to re-create the heavens on the Earth. Others have found mathematical constants like pi and phi mysteriously coded into the structure. Maybe aliens built them*. The proponents of such ideas are sometimes referred to as pyramidiots. There is little evidence to support most of these theories, but they are also difficult to disprove. That's not to lend them any credence. If I were to tell you that the Great Pyramid was originally built as a ceremonial storage chamber for cow manure, you would hopefully doubt me, but you can't really disprove the idea.

St Basil's Cathedral: The onion-domed church beside the Kremlin in Moscow is such a beauty that, according to legend, Tsar Ivan the Terrible had the architect blinded so he could never surpass this masterpiece. The story is almost certainly untrue, as architect Postnik Yakovlev (dates unknown but the cathedral was built between 1555 and 1560) is known to have designed other, later buildings.

* FOOTNOTE As I write, the headline 'Alien Coffins Discovered Near Pyramids' is in the news.

Other Art Forms

Having dealt with painting, sculpture and
architecture, we move on to other visual arts.

The invention of photography was seen as a major threat to artists

'From today painting is dead.'

So, supposedly, said the French artist Paul Delaroche (1797–1856) upon glimpsing an early photograph, or daguerreotype, around 1839. What would be the point of slaving away for hours over a canvas, when one could capture a subject in seconds, with the click of a button?

Little more than a decade later, Delaroche's near namesake Eugène Delacroix (1798–1863), gave a very different viewpoint: 'If a man of genius uses daguerreotype as it ought to be used, he will raise himself to heights unknown to us'.

The two views are a sample from a wider debate about photography that took many turns over the 19th century. Some did worry about the disruptive potential of the camera. Others were giddy to experiment. As things transpired, the new medium turned out to be less of a threat to the artist, and more of an aid. Just as video failed to kill the radio star, and

e-books have yet to supplant the humble paperback, so too were artists and photographers able to thrive together.

The earliest photographic images, by the likes of Henry Fox Talbot (1800–77) and Louis Daguerre (1787–1851), were created in the 1830s. They caused an immediate sensation. Photography was described as 'painting with solar light', 'the sun's drawing' or 'the pencil of Nature' – suggesting the process was not just an alternative to painting, but a purer, more natural form of art. Even John Ruskin (1819–1900), an often curmudgeonly critic of anything that smacked of progress, described photography as 'the most marvellous invention of the century'. He amassed large numbers of daguerreotypes to assist in his compositions, but later grew cold to the technology.

In its early years, photography was considered and described as an art form in its own right. In parallel, many painters adopted the camera as a tool of the trade. The landscape painter no longer had to deal with the vagaries of the weather and the shifting of shadows. He or she could make a quick preparatory sketch *en plein air*, take photographs to capture the scene, then finish the details off back in the studio with reference to the photos. Artists could now capture momentary lighting conditions that might vanish on the whim of a cloud, or else paint winter scenes that would have frozen the palettes (and fingers) of dogged traditionalists. A fair amount of recourse to memory and imagination was still required – after all, early photography could not capture colour – but the camera was a welcome new tool.

The convenience of the lens was also harnessed by portraitists, and it was in this arena that the technology most directly competed with the artist's brush. As an anonymous newspaper hack from 1843 described it: '... the actual sitting does not exceed three minutes, and the whole process of finishing and framing does not occupy more than a quarter of an hour, so that the great objection of tediousness and trouble, which are inseparable from oil painting, is here done away with, and the cost is also comparatively small, from one to two guineas'.

That same year, David Octavius Hill (1802–70) showed just how useful the camera could be. Hill wanted to make a commemorative painting of The First General Assembly of the Free Church of Scotland. To do so

while the Assembly was in session would have been an impossible task, for some 1,500 people were present. Instead, Hill acquired photographs of many of those in attendance, and used these to paint the ensemble. His sprawling group portrait contains 457 faces, accurately rendered. Most are high-ranking members of the clergy but – in what might be counted as the world's first instance of photobombing – we also see a group of curious fishermen peering in through a window.

Photography found other uses, too; the technology was soon adopted by art schools. Hitherto, students would have to travel the world to see a wide spread of Old-Master paintings, or else examine unfaithful copies. Now they could familiarize themselves with all the great works thanks to photographic reproduction. Details of costume and furnishings could also be acquired from stock photos, bypassing the need to paint these expensive props from life. The lens could also be employed to help publicize and market new works of art.

As well as working from the photographs of others, many artists also became experts in camera technique. The technology was particularly useful when preparing a self-portrait. Working from a photograph, the artist could now depict him or herself in any pose without the constraints and discomfort of looking in a mirror.

The link between photography and painting found its most famous expression in the work of the Pre-Raphaelites. Dante Gabriel Rossetti (1828–82) in particular had numerous photographic portraits taken of his model (and lover) Jane Morris, as prep work for some of his most famous paintings. But he was far from alone. American painter Thomas Eakins (1844–1916) was another keen photographer. During the 1880s, he traced over photographs to bring a sense of realism to his paintings.

Photography could undoubtedly be a useful tool for artists, but inspiration also flowed the other way. It was not uncommon for photographers to re-create famous paintings, their subjects dressed in period costume and suitably posed in a *tableau vivant*. The Pre-Raphaelite Henry Wallis (1830–1916) is most noted for his *The Death of Chatterton*, which shows the eponymous poet slumped in his London garret after taking poison. John Ruskin described the painting as 'faultless and wonderful'. Reproductions

were in such demand that one enterprising individual by the name of James Robinson hired an actor, re-staged the scene and captured a stereo photograph, which he then put on sale. Robinson was taken to court for producing a 'piratical imitation', but did not have to pay damages.

Despite its usefulness, photography does have its limitations. A traditional artist could play with lighting, exaggerate features and generally dispense with reality to achieve a desired effect. In the words of the art critic Philip Hamerton (1834–94)*, 'in his way of interpreting Nature's light, [a painter] has opportunities of compromise and compensation which the unthinking photograph cannot'. His point is that a photographer cannot portray 'two truths at once'. One might accurately capture the ripples of light on the sea, but at the expense of a washed-out sky or shoreline. The artist, by contrast, can paint all aspects as she pleases, shifting focus and lighting conditions at whim.

There were always doom-mongers who believed that photography would see off more established fine arts. The fear was never realized. When photography first appeared, it was too crude to pose much threat to the artist. Nor could it ever replicate the painterly textures of the canvas. By the time the technology matured, photography had become an important tool for artists rather than a rival. And then, too, art was changing, partly as a response to photography. As the 19th century progressed, the great artistic movements were concerned with capturing movement, change and human perception. Impressionism and other schools began to depict the world in ways that could not be achieved with a camera. Accurate representation fell out of fashion, and with it the whole argument about the fidelity of the photograph. The giants of the late 19th and early 20th century, including van Gogh (1853–90), Picasso (1881–1973), Degas (1834–1917), Gauguin (1848–1903) and Matisse (1869–1954), all used photography to aid their compositions. The relationship between the two media is complex, fascinating and ever-changing, but rarely a story of direct rivalry.

* FOOTNOTE In his 1871 book *Thoughts About Art*, a wide-ranging and immensely readable account of the Victorian art world, from gallery display to the relationship between art and science.

Walt Disney designed Mickey Mouse, who first appeared in Steamboat Willie

The typical mouse lives for a year or two. At the time of writing, Mickey is approaching his 90th birthday, and still going strong.

Walt Disney (1901–66) is often given sole credit for inventing this longest lived of all screen characters. The mouse was supposedly based on his own pet. But the design was largely down to his collaborator Ub Iwerks (1901–71). Although Disney made some initial sketches, it was Iwerks who fancied them up into something that could be animated, eventually arriving at the familiar character we all know today. Early cartoons are presented as 'A Walt Disney comic by Ub Iwerks'.

Disney, of course, played a large part in shaping Mickey's personality, and also provided his voice, but it was very much a collaboration with Iwerks wielding the pen. To quote one anonymous studio hand: 'Ub designed Mickey's physical appearance, but Walt gave him his soul.'

Mickey's official birthday is 18 November 1928. This was the release date of the short film *Steamboat Willie*. It was the first time the rodent and his girlfriend Minnie appeared on public screens, and also their first appearance with sound. But there were two earlier Mickey films. *Plane Crazy* and *The Gallopin' Gaucho** were shown to test audiences a few months before.

Although these predate the more famous film, they didn't gain public release until 1929, after *Steamboat Willie* had already established the distinctive character.

Oh, and the only other thing we all know about Disney – that his head was cryogenically frozen – is also untrue. The cartoonist was cremated shortly after his death on 15 December 1966. Disney is thought to have expressed an interest in cryogenics, but never put it down in his will. The urban legend arose about a decade later but remains stubbornly persistent. Ironically, the highest grossing animated film of all time is Disney's *Frozen*.

* FOOTNOTE Both readily available online. The latter features our murine hero chomping on a cigarette and downing a tankard of frothing ale.

The famous tapestry made in Bayeux shows how King Harold took an arrow in the eye at the Battle of Hastings

The Bayeux Tapestry is unique. Both artwork and historical document, the embroidered linen tells the story of the events leading up to the Norman invasion of England in 1066, culminating in the Battle of Hastings. It is a stunning and ambitious piece of work. At almost 70m (230ft) long, you could hang 130 *Mona Lisas* in the same space, or else drape the tapestry over eight copies of the *Last Supper*. You'd need strong nails, mind. The tapestry tips the scales at 350kg (772lb), the equivalent of ten double mattresses. Nothing quite like it survives from the medieval period.

Like any iconic object, the Bayeux Tapestry is an attractor of tall tales and misconceptions. Even its name is misleading. Although the work has long been kept in the northern French town of Bayeux, most scholars believe it was crafted in England, probably in Kent. All the clues point to an English origin, including subtleties of language, the choice of content and the use of certain vegetable dyes.

Nor is it technically a tapestry. The various knights, horses and arrows are embroidered onto the cloth as, indeed, is the naked, squatting man

hAROLD:-REX:-INTERFEC TVS:EST

whose massive genitalia markedly enliven the border of the 15th scene. A true tapestry is woven, not embroidered. Nevertheless, the work is usually referred to as a tapestry, as are other embroidered works from the period.

The tapestry's most famous scene, in which King Harold takes an arrow in the eye, is problematic for several reasons. First, there is good evidence that the arrow is a repair addition to the tapestry rather than an original feature. Second, the angle of the shaft appears to miss the eye altogether. Take a look online: it's clearly going into the forehead. Third, pin holes suggest that the figure may once have wielded a lance instead of absorbing an arrow. Fourth, the earliest account of Harold's death has him dismembered by a quartet of knights rather than struck down by a flying shaft. (It could be that both happened. Harold was hit by an arrow, then finished off by the soldiers. We just don't know.) And finally, the arrow-afflicted character in the tapestry might not even be Harold. His name does appear close by in the same panel, but several other fallen Englishmen also languish nearby.

The tapestry has been repaired and retouched over the centuries but retains most of the original material. It ends abruptly, as though a piece is missing. It is here that some suspect a curious bit of forgery. The final caption (or *titulus* to use the technical term) reads *Et fuga verterunt Angli*, which means 'and the English turned in flight'. It is commonly stated (including on Wikipedia) that the words are entirely spurious and were added during the Napoleonic wars of the early 19th century, as an anti-English sentiment. However, references to the *titulus* can be found in earlier accounts, including – somewhat improbably – a 1775 book on the history of Manchester*.

So, the Bayeux Tapestry was not made in Bayeux, is not a tapestry, and quite possibly misrepresents the death of King Harold. As a final ignominy, the conflict took place not at Hastings, but a few miles north-west near a town now called Battle. None of this nitpicking, though, can detract from one of the world's great medieval treasures.

* FOOTNOTE *The History of Manchester in Four Books: Volume 2*, 1775, by Reverend John Whitaker. A still earlier account to mention the flight of the English can be found in the 1733 title *Histoire de l'Académie Royale des Inscriptions et Belles Lettres*. Both can be accessed free on Google Books.

Most street artists are teenage boys who illegally spray on walls

The urge to write on walls is as old as walls. One of the main take-home messages from a trip to Pompeii is just how much the populace enjoyed scrawling in public places. Some of these Roman etchings are so crude that they cannot be repeated in a family-friendly book. Let's just say that 'Restituta, take off your tunic, please, and show us your hairy privates' is among the mildest messages preserved on the walls of that ill-fated town, destroyed by the eruption of Vesuvius in 79CE.

Even older examples exist. Five hundred years earlier on the Aegean island of Astypalaia, a gentleman by the name of Dion chiselled racy declarations onto a rock, then added a brace of phalluses for good measure.* Another graffito from the mid-6th century BCE recorded that 'Nikasitimos was here mounting Timiona'. This association with graffiti and male egotism or delinquency has survived to our own times. Many people, I think, still regard graffiti as the sole preserve of teenage boys. This just ain't so – and never has been.

* FOOTNOTE The sum total of your life's achievements will almost certainly be forgotten in a generation or two. Yet this Dion character has achieved immortality by drawing a not-very-good penis onto a rock. You might as well give up now.

Graffiti comes in many styles and flavours, and is prompted by all sorts of motivations. The earliest forms of modern graffiti renewed that ancient urge to mark territory. While we learn from the basilica at Pompeii that 'Gaius Pumidius Dipilus was here on October 3rd', we might read from a 21st-century railway siding that 'Tox' paid a visit with his spray can in 2006. This gratuitous self-promotion is the simplest form of graffiti – often called tagging. Taggers commonly target railways, which offer plenty of wall space and high visibility, but they can be found throughout the urban environment. Their handiwork can range from a simple repetition of a name, to more elaborate 'throw-ups' (usually, some form of bubble writing) and still more complex patterns of near-abstract lettering.

These acts of vandalism are but one avenue of graffiti, which has since blossomed into a rich variety of forms. Spray paint is still the most common means of expression, but artists will routinely use paste-ups, stickers and sculpture. Some even incorporate light or video projections and 3D effects into their work.

One of the biggest misconceptions about street art and graffiti is that it is always illegal. Large works are, in fact, often done with the permission of the property owner. Sometimes the work is commissioned, and the artist makes money from decorating the side of a house or the wall of an office. Boutique hotels from Brooklyn to Budapest have invited local street artists to liven up their reception areas and bedrooms. This increasingly professionalized realm of creativity even has brokerage agencies. These bring together property owners, big brands and street artists to create legal murals. They also work with local authorities to find spaces for spraying. It's all a far cry from a gang of taggers scaling a fence in the dead of night.

This sophisticated scene attracts artists from all demographics, not just the teenage boys who stereotypically wield the spray can. The most famous street artists are often considerably older than people expect. It's only natural when you think about it, for it takes time to make a name for yourself in any field. To start with the most famous name, Banksy has been active since 1990 and is thought to be in his 40s (a number of sources give a birth date of 1974). Ben Eine and Shepard Fairey were both born in 1970, in London and Charleston respectively. They are spring chickens compared

to some of the earliest street artists. Blek le Rat, the Parisian pioneer of stencil art and a big influence on Banksy, was born in 1952, and is still active. Thierry Noir, noted for his paintings on the Berlin Wall, was born in Lyon in 1958.

So much for street art being a young person's game. But is it still male-dominated? The short answer is yes, but not as much as you might think. Major female artists include Swoon (born 1977), an American who throws up life-size paper cut-outs of people. Lady Pink started tagging in the 1970s, and now paints figurative work around New York City. The Guerrilla Girls – noted for their decades-long campaign to bring parity to women artists – also use street posters and interventions to get their message across. Meanwhile, the record for the world's largest spray-painted mural was broken by an all-female collective in 2014, when over 100 artists hit up a whole street in London.

Nor is street art restricted to outdoor spaces. Most big cities possess galleries dedicated to street art, selling prints and other items. Some shows have taken over entire office blocks, while Banksy's infamous 'Dismaland' project saw a 'family theme park unsuitable for children' filled with installations inspired by street art. Large establishment galleries and private collectors are also paying close attention to the genre. Several of Banksy's key works have sold at auction for over $1 million, and the artist has an estimated net worth of at least $20 million. While most street artists can only dream of such an income, there is certainly cash to be had for artists with the talent and persistence.

Despite support from high places, and growing commercial value, street art has yet to achieve the level of respectability that a studio-based contemporary artist might expect. Lines are blurring and attitudes are shifting. The furtively scrawled penis or railway tag will no doubt always be with us, but the more accomplished acts of graffiti and street art are now considered major works of fine art.

Conceptual art is a load of rubbish that anyone could put together

I remember getting very excited in 2009, when it was announced that London Underground was to get its first permanent work of art for a quarter of a century. The piece, known as *Full Circle* by Knut Henrik Henriksen (born 1970), was installed in the remodelled passages of King's Cross Tube Station. I went along the next day, not really knowing what to expect other than a large-scale artwork somewhere in the labyrinth of tunnels beneath King's Cross. I couldn't find it.

Eventually, I tracked the piece down to the end of a corridor on the Northern Line. It consists of nothing more than a lip-shaped piece of metal, upended like a lopsided crescent moon.

'Is that it?' I thought. Couldn't they have done something more imaginative? At the time I dismissed *Full Circle* as a worthless bit of art that anyone could have cobbled together. It's a charge often levelled at modern art in general, and conceptual art in particular.

So what was going on at King's Cross? I should have been tipped off by the title. That lip of metal represents the missing piece of any tunnel on the London Underground, the part that completes the full circle. Most of the subterranean tubes of the underground network were bored out with circular cutting heads. Yet we never see the lower part of that cross-section. It is always filled with track beds and rails, while the pedestrian passages are levelled off to provide flat floors. I've travelled thousands of miles by London Underground. I've written dozens of articles about the Tube. And yet I'd never once considered this invisible portion of tunnel. It took me years to work it out, but that seemingly mundane installation had caused me to reconsider an environment I thought I knew intimately. That moment of revelation was as magical as anything seen in an Old-Master painting or Impressionist fancy. Conceptual art requires work on the part of the viewer, but that makes it all the more powerful, and personal, when you finally 'get' it.

Anyone who's ever got to first base with conceptual art will have had a similar experience – an 'Aha!' moment when a previously unremarkable or confusing object is suddenly imbued with meaning. Conceptual art has many progenitors. We've already explored Marcel Duchamp's (1887–1968) urinal more than is wholesome, but a further mention here cannot be

avoided. That porcelain intervention was well named as *Fountain*, for this was the nozzle that started it all.

One of the most original and thought-provoking conceptual artists was Piero Manzoni (1933–63). In 1960 and 1961, this Italian artist orchestrated a number of art stunts that lie somewhere on the continuum between student prank and outright genius. In *Base of the World*, Manzoni simply placed a metal platform upside down in a field. The whole planet had been put onto a plinth and declared a work of art in its own right. The artist was now redundant.

Around the same time, Manzoni curled out his most notorious work. *Artist's Shit* is a series of home-made turds presented in 90 sealed cans. Labelled up as 'Merda d'artista' the cans would not look out of place on a supermarket shelf next to the tuna and salmon. That alone guaranteed attention, but the piece has hidden depths that go beyond the taboo of feculence. Manzoni declared that each 30g (1oz) can was worth its weight in gold – around $37 in non-adjusted 1961 prices. The 90 cans have been sold many times over the ensuing decades. One tin fetched an incredible £182,500 at auction in 2015 – well over 100 times its weight in gold. Is this truly conceptual art, or just a bit of scatalogical silliness? If you're still undecided, here's the punchline: nobody has any idea if the cans actually do contain Manzoni's backside-burgers. He could have filled them with anything. Nobody has ever opened one. To do so would damage the object, and thereby devalue it. This is a form of art that is not pretty to look at (quite the opposite), but really makes the viewer think and consider.

And thereby hangs the power of conceptual art. Manzoni's upside-down plinth in a field is not a beautiful object like the *Mona Lisa*, nor a work of intricate skill and patience like the Sistine Chapel ceiling. Yet programmed into it is a puzzle and a paradox that, once spotted, can twist our views of the world. *Artist's Shit* might raise a smirk in the gallery, but once we separate the back story from the backside story, the work speaks eloquently about perception, expectation and trust. Conceptual art stands or falls on the strength of the idea behind it, not on its outward appearance. Yes, we could all defecate into a can and call it art, but that's to miss the point (if, hopefully, not the can).

Some conceptual artists do away with physical objects altogether. In an infamous 1965 work, Yoko Ono (born 1933) sat on a stage while members of the audience took it in turns to snip off pieces from her dress. *Cut Piece*, as her performance art is known, explores deep psychological issues. Would you get up from the audience to participate? Which part of her dress would you attack? How would it make you feel? How dark will your thoughts go?

Conceptual artists often incorporate technology into their work. One of the most visible is US artist Jenny Holzer (born 1950). She makes her mark, without actually making a mark, by projecting pithy but thought-provoking messages onto buildings. To see phrases like 'Expiring for love is beautiful and stupid' or simply 'I feel you' writ large onto a familiar landscape or building is very powerful. The phrase might have no intrinsic meaning, but each passer-by will interpret those words in their own unique way.

This is another respect in which conceptual art differs from, and in some ways surpasses, more traditional art. Conceptual art is about you, the viewer. What do you think? How does this weird intervention make you feel? What strange associations does it conjure in your mind? A well-executed painting can be a joy to behold and contain its own hidden messages, but it's unlikely to make you question your assumptions about the world, or reassess your environment.

I've passed by *Full Circle* on numerous occasions. I've never once seen anybody stop and consider the work. It hides in plain sight, and is easily mistaken for a random bit of wall panelling. It is quite possibly the most bypassed piece of art in the world. Millions ignore it every year. All of which makes the work even more special ... once you're in on the concept.

Art's Daftest Conspiracy Theories

CENSORED

Many of the world's most famous paintings and painters have attracted the attention of conspiracy theorists. By their very nature, most of these ideas are not testable and can't be proven wrong. I record them here for you to make up your own mind.

The Mona Lisa is actually a hidden self-portrait of Leonardo

Among works of art – indeed, the whole of human creativity – nothing attracts speculation as much as Leonardo da Vinci's (1452–1519) *Mona Lisa*. Who was she? Why does she so enchant? What's with that half-smile? Has anyone ever written anything about that painting, *ever*, without using the word 'enigmatic'? Those questions have prompted some unusual answers over the years. The wackiest of all posits that the dark-haired belle is a self-portrait of Leonardo.

The identity of the sitter would seem to be beyond doubt. 'Leonardo undertook to paint, for Francesco del Giocondo, the portrait of Mona Lisa, his wife.' So said the famous art historian Giorgio Vasari (1511–74). He was writing 31 years after Leonardo's death, but this was a biographer who immersed himself in, and contributed much to, Renaissance art. Vasari was the leading historian of his times. He made the odd mistake here and there, but we can generally rely on his knowledge.

Vasari's statement was backed up by a discovery in 2005. A scholar at Heidelberg University chanced across a handwritten note in the margin of a book about classical Rome. The writing is dated 1503 and is by Leonardo's contemporary Agostino Vespucci. It notes that the master is working on a portrait of Lisa del Giocondo.

So, assuming the note is genuine, we know from primary evidence that Leonardo was painting someone called Lisa in 1503. Half a century later, a respected historian confirmed that *Mona Lisa* (which effectively means 'my lady Lisa') is that painting. Furthermore, the portrait has acquired the nickname *La Gioconda* in Italian, which roughly translates as 'the jocund' or 'the jolly'. It's a fairly obvious pun on the sitter's name, del Giocondo. Everything fits together neatly. Case closed.

Of course, it's never that simple. Most art historians, since the 2005 discovery, now agree that del Giocondo was the subject. But there's just enough wiggle room and uncertainty to permit rival theories. Most peculiar of all is the notion that Leonardo himself was the subject, at least initially.

Where does this come from? The artist Lillian Schwartz (born 1927) is a good starting point. Schwartz is a pioneer of computer-enabled artwork. One of her most famous images shows a composite face. The left half comes from *Mona Lisa*, the other from a supposed portrait of Leonardo. The two halves match up well, with eyes, nose and mouth all in alignment. Others, too, have noted that the *Mona* has unusually masculine proportions. Did Leonardo really use his own face as the model for his famous portrait? It's an intriguing speculation, but no more, and certainly not more persuasive than the evidence for the conventional story. Indeed, it's not even certain if the half-portrait of Leonardo used by Schwartz is itself an authentic likeness of the master. The image, known as *Portrait of a Man With Red Chalk*, is certainly by Leonardo, and is widely used in books, TV programmes and films as though it were a self-portrait. But there is some doubt.

Nevertheless, the idea that *Mona Lisa* might show Leonardo da Vinci in drag has been taken seriously by many. Some even want to track down the remains of the artist – thought to lie in France – in an attempt to solve the mystery. With an intact skull, anatomists could rebuild in clay the musculature of Leonardo's face. Such an endeavour, fraught with complications and caveats, would go nowhere near proving the connection. It would, though, make for a lucrative TV tie-in.

Whoever Mona Lisa was, she retains her hold on the popular imagination half a millennium after she (or he) sat for that portrait. An estimated six

million people visit the painting at the Louvre every year. One must join the back of a sizeable crowd to squint for a view. She's much smaller than you might imagine. She's also painted onto a wooden panel, not canvas.

Mona Lisa has not always been a superstar. The painting has long been venerated in art circles, and even decorated the bedroom of Napoleon I for a short time. Yet until the mid-19th century, she was nothing like a household name. By the 20th century, Leonardo had risen up the pantheon of Renaissance geniuses to the point where *Mona Lisa* was considered one of the three most valuable paintings in the world. Everyone was interested in *La Gioconda*, including those with light fingers. When she disappeared from the Louvre on 21 August 1911, the theft made headline news. The poet Guillaume Apollinaire was implicated, and even Picasso was on the list of suspects. The portrait finally showed up two years later. It had been smuggled out by a Louvre employee of Italian nationality, who thought the work should be returned to its country of origin – though he may have been motivated by the black market for Old-Master forgeries.

It was the theft of the century, and sparked a heap of public interest. The recovered *Mona Lisa* had acquired yet another layer of fame since bolstered by an endless stream of parodies. Most famously, in 1919 Marcel Duchamp (1887–1968) painted a moustache and beard onto a cheap postcard of *La Gioconda*, calling his work L.H.O.O.Q*. Other artists followed suit, including Salvador Dalí (1904–89), René Magritte (1898–1967) and Banksy (born 1974). Search online for '*Mona Lisa* parody' and you'll find her clutching a light sabre or with the face of Kim Kardashian. She really is an icon for all generations.

Is she a fake? That's another conspiracy theory that resurfaces every few decades. The clamour was loudest after her recovery following the 1911 theft. Rumours circulated that she hadn't been recovered at all, and that a precise replica now took her place in the Louvre.

* FOOTNOTE A clever, if lewd, pun: when pronounced in French, the sequence of letters sounds like *Elle a chaud au cui*, or 'she is hot in the arse'.

The conspiracies ran even deeper. In 1912, while the painting was still missing, one art critic claimed it had never left the Louvre. He had it on good authority that *La Gioconda* had perished in a sulphuric acid attack, to be covertly replaced by a replica. 'As long as there was any hope of restoring the original, the substitute was left in the familiar frame,' he tells us. 'When certain visitors were beginning to whisper their doubts about the picture ... the substitute was taken out and very likely thrown into the fire.' The theft, then, was just a story to cover the Louvre's ineptitude.

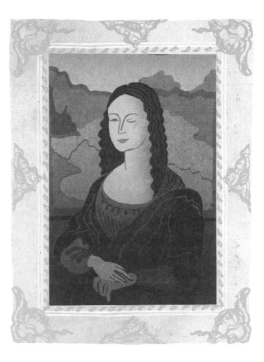

And finally, a long-lost conspiracy theory that I recently chanced across in the newspaper archives*. *The Morning Chronicle* of 13 July 1813 contains a snippet concerning a theft of the *Mona Lisa* from the Fontainebleau Gallery, where she was displayed until 1695. The article goes on to refer to the painting 'now exhibited in the Louvre, being an acknowledged copy'. I can't find any other reference either to this supposed theft, or the doubts of authenticity of the time. Nonsense, no doubt. But I'll just leave this here in case any modern conspiracy theorists want to take up the trail.

* FOOTNOTE This and the acid-attack theory were both discovered in the wonderful British Newspaper Archive website.

Michelangelo hid anatomical sketches in the Sistine Chapel

Picture the ceiling of the Sistine Chapel in your mind's eye. Chances are, you're imagining that pre-eminent panel in which God gives the spark of life to Adam, fingers almost touching as the Lord reaches down to his creation. The scene, painted by Michelangelo (1475–1564) in the early 16th century, is one of the defining images of Renaissance art. It's also the first depiction of God as a bearded man in the clouds, since copied and parodied without end.

Such is the fame and importance of this panel, that it comes as a surprise to learn that the *Creation of Adam* represents just 3 per cent of the painted area of the ceiling. That's like envisaging the *Mona Lisa* and remembering only her neck. God and Adam are just two of the 300 or so figures painted here by Michelangelo. It really is a cavalcade of genius.

Like the subjects of any super-famous work of art, Adam and God have attracted plenty of speculation over the centuries. Michelangelo's depiction is entirely without precedent. Something exciting and exceptional was going on inside his brain when he first sketched out this scene. Could it be that Michelangelo was inspired by the brain itself?

That's one theory, proposed in a highly respected medical journal in 1990. A physician named Frank Meshberger pointed out the striking similarities between the divine imagery in Michelangelo's panel and the human brain. Take a look online. God and his entourage appear to be sitting within a

pink, arcing structure. It could be a billowing shroud, but it also looks like a human brain seen from the side. The plot thickens. The shape and position of God's body seem to follow the notable grooves of the brain, while his companions recall further features of that organ.

There might be something in this. Michelangelo is known to have made close studies of human anatomy as preparation for his art. He was slicing into corpses while still a teenager and would have been familiar with the main structures of the brain. It's not beyond the realms of possibility that he incorporated such motifs into the panel. After all, he's showing the creation of man, who is set apart from the animals by his intellect and creativity – functions of the brain.

Some have even pointed out that the gap between the fingers of God and Adam is reminiscent of a synapse. A synapse, crudely put, is the space between two brain cells. The panel supposedly shows God giving the spark of life to Adam. But here's the thing: Adam is already alive, even though God's index finger has yet to touch him. It's as though the spark of life has jumped the gap. And that's just what happens in a synapse, where two nerve cells communicate (via small molecules) without ever touching. It's a lovely coincidence, but only that. Synapses and brain cells are tiny things, way beyond the capabilities of the early 16th century dissection table. The first cell was not visualized down a microscope until later in the century, but it would take until the 20th century for scientists to describe the synapse and the transmission of nerve impulses.

The anatomical comparisons just keep on coming, though. In an adjacent panel, *Separation of Land and Water*, God lunges from what appears to be a giant kidney. This was a particularly clamorous organ for Michelangelo, who suffered from painful stones. Most recently, another respected medical journal published a study of yet another ceiling panel, *The Separation of Light from Darkness*. Here, God is shown from a very peculiar angle, his head thrown back to reveal a curiously bulbous throat. Art historians have long argued over why Michelangelo should afflict God with a begoitered neck. Was it a veiled insult to the church, or simply an error? Some now think that the peculiar anatomy is a hidden representation of a human brain stem. One can even intuit a spinal cord, corresponding to the opening of God's robes.

Others have found reproductive organs concealed within the frescos. Turning again to the *Creation of Adam*, that brain-shaped carapace around God might equally be likened to a uterus. It makes sense. The fresco depicts the ultimate act of creation, the symbolic birth of man. Other uterine motifs flank the ceiling in the guise of ram skulls, with horns that curl like Fallopian tubes. Upward and downward pointing triangles abound – ancient symbols of male and female genitalia (or just the way that the ceiling was built). It's a Freudian wonderland up there. The green scarf, which dangles from God's abode, could represent a freshly cut umbilical cord. If this all sounds rather implausible, weigh it up against the biggest mystery on the Sistine Chapel's ceiling: why does Adam have a belly button?

And why should Michelangelo festoon his masterpiece with hidden anatomy – if indeed, he did? Theories abound. The artist may have been mocking the Pope. The Catholic church was somewhat squeamish when it came to depictions of flesh. The 1965 film *The Agony and the Ecstasy* re-creates a fiery exchange between Michelangelo and the Pope, in which the pontiff bemoans the amount of nudity in the artist's panels, including a naked Noah. 'Am I to improve on Holy Writ?' asks Michelangelo, 'and put breaches on him?'. Michelangelo got his way, but may have hidden further anatomical 'Easter eggs' to cock a snook at the church*.

* FOOTNOTE But the censors with censers were circling. Michelangelo later returned to the Sistine Chapel to paint his monumental *Last Judgment* over one wall. Its nudity caused such a furore, you'd think it was the end of the world (which, in one sense, it was). Papal official Biagio da Cesena declared the unfolding work as better suited to a roadside tavern or public bath than to the Pope's chapel. In a warning to art critics everywhere, Michelangelo responded by painting Cesena into his masterpiece. He's easy to spot: look for the figure with the donkey ears, languishing in Hell. After Michelangelo's death, the Pope's censors defaced the fresco with loincloths and fig leaves. Most have now been removed.

Van Gogh was colour-blind

Van Gogh's (1853–90) use of colour was highly distinctive. Even those who know nothing about art can pick his work out from, say, a Cézanne (1839–1906) or Gauguin (1848–1903). Those exquisite blues and yellows, often contrasted with unlikely shades of red or green, give the artist a unique fingerprint. This has led some to speculate that the master had a mild form of colour-blindness. Was he simply painting what he saw, unaware that his vision differed from that of most other people?

It is possible to simulate colour-blindness using special filters. Under one particular filter, corresponding to a gentle form of colour-blindness, van Gogh's paintings consistently take on a more realistic hue. It's like he had no idea that the subtle apricot tones were really a dirty red, or that his bright orange corn field was, in reality, straw yellow to most people.

The idea is not without precedent. Claude Monet (1840–1926), for example, suffered from cataracts later in life. The paintings he made during this period have a deeper red tone than earlier works, consistent with the change in colour vision often reported by cataract sufferers. After removal of his cataracts, Monet's water lily paintings took on a strikingly bluer hue – and some have even suggested he was now able to see certain wavelengths of UV light, like some kind of lily-obsessed vampire.

So it's perfectly possible that van Gogh enjoyed abnormal colour vision. Then again, it was not unusual for artists to use unnatural colours at this time. In Gauguin's *Le Christ Jaune* (1889), for example, the Saviour is so yellow that he looks for all the world like a character from *The Simpsons*. Until someone clones the Frenchman, we'll never know.

Goya's Black Paintings were forgeries, made after his death

In contrast to van Gogh's sublime use of colour, the Black Paintings of Francisco Goya (1746–1828) show the world in anything but a joyful light. The Spaniard was in his 70s, wracked with illness and increasingly misanthropic when he painted this bleak series of 14 (possibly 15) images. The most famous shows the god Saturn mauling the bloody carcass of his son. It's ghastly. Another shows two spectral figures pummelling one another with cudgels. Still others are populated with toothless grinagogs and creatures of dark fable. Goya painted these cheerless scenes directly onto the walls of his home near Madrid, like a teenage Goth bedecking his bedroom with Death Metal posters. The murals were later removed to the nearby Museo del Prado.

These dark images are not just disturbing, but also puzzling. Goya seems to have created the pieces for what we might call personal consumption, rather than public show. He did not give any of them names, and their present titles were dreamed up by art historians. The works remained obscure for half a century after Goya's death, until they were finally transferred to canvas in 1874 and later put on public display.

Little documentation exists to describe the works *in situ* during Goya's lifetime. You'd think one of his house guests might have remembered the rabid cannibal god under the stairs, but no diary mentions these most startling works. We do not know for sure when they were painted.

This vacuum of information has sucked in speculation. Art historian Juan José Junquera has led the charge to declare them fakes. His reading of a deed transfer suggests that Goya's house had only one floor during the artist's lifetime. Yet the murals are later documented over two storeys. The natural deduction is that a second floor was added after Goya's death, and the murals could not have been painted before that time.

The finger is pointed at Goya's son, Javier de Goya, who may have imitated his late father's style for fun. Or perhaps the culprit was profligate grandson Mariano Goya, who could have passed the works off as Goya originals to increase the value of the house. Most Goya experts disagree, arguing that both the technique and subject matter are a close match for other works by the master. That said, the paintings are much retouched since Goya's time, and suffered during the wrench from mural to canvas – a definitive attribution is tricky. The jury is still out on this one, but it wouldn't be the first time that Goya paintings have been downgraded.

Rembrandt used mirrors and lenses to paint his masterpieces

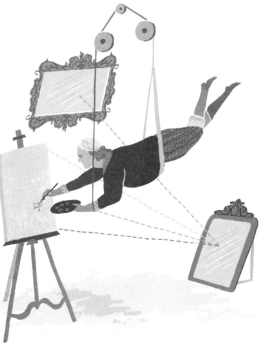

'Did Rembrandt TRACE his self-portraits?' So flapped the *Daily Mail* in 2016. The reactionary newspaper had cottoned on to a long-acknowledged truth that painters sometimes employ tools other than brushes. By using mirrors and lenses, so it's said, Rembrandt (1606–69) was able to reflect his likeness onto a sheet of copper, a surface polished enough to pick up the reflection. He could then trace around it.

There's plenty to recommend the idea. For starters, several of Rembrandt's most characterful self-portraits are painted onto copper surfaces. One c.1628 portrait shows the master chuckling away while glancing sideways. This is something of a novelty. To see why, try this little experiment at home. Grab a hand mirror, a pencil and some paper. Now, pull a striking facial pose – a maniacal grin or a puzzled frown. What happens when you

attempt to draw yourself by looking into the mirror? You'll find that it's hard to maintain the pose as your eyes go back and forth between the paper and the reflection. This is why most self-portraits show their creators with a neutral expression. Rembrandt's laughing likeness therefore strikes us as unusual. Perhaps, then, he used a series of mirrors to project his grinning countenance straight onto the copper, and simply sketched around it without the need to shift his focus.

In addition, many of Rembrandt's self-portraits are taken in deep chiaroscuro, a strong contrast of light and dark. This matches the conditions needed to get a strong reflection onto the copper. If Rembrandt had been sitting in a brightly lit gazebo, the background light would have made the reflection of his face hard to pick out on the copper surface. By illuminating his face, but not his surroundings, he'd have got a sharper reflection. This may be one reason that so many Rembrandt selfies have dark, plain backgrounds.

Or not. Rembrandt was unquestionably one of the greatest draughtsmen of all time. Some have argued that there is no need to invoke these cheap conjuring tricks to explain his technique. The master could easily have painted his own likeness in any expression he chose.

Still, the theory is supported by hints in the literature of the time. Some artists may have used a device called a camera obscura to trace outlines. This technique uses a hole in a wall, fitted with a lens, to project an upside-down image onto the opposite wall. Although faint, the image retains the colour and shape of the original, allowing a faithful reproduction. It is commonly speculated that Johannes Vermeer (1632–75) used such a device to pull off his incredibly lifelike paintings. No record from the time supports this, but there is plenty of circumstantial evidence.

These ideas were first proposed seriously by artist David Hockney (born 1937) and physicist Charles M. Falco (born 1948). The so-called Hockney-Falco thesis claims that advances in realism after the Renaissance were more down to the use of optical technology than any flair in technique. The idea remains controversial, but is by no means implausible.

Walter Sickert was Jack the Ripper

Walter Sickert (1860–1942) is one of the most intriguing painters of the late 19th and early 20th century. His canvases are wide-ranging, but often show scenes of poverty and squalor painted in sombre hues. The Englishman's familiarity with the seedier side of Victorian London has earned him a place in that most unenviable of clubs: candidates for Jack the Ripper.

Sickert was first fingered for the crimes in the 1970s. The journalist Stephen Knight identified the painter as a Ripper accomplice in his 1976 book *Jack the Ripper: The Final Solution*. A stage play followed. Contrary to that book's title dozens, if not hundreds, of rival theories have since found their way onto the lucrative bookshelf entitled 'I know who Jack the Ripper was'. Sickert remains a popular choice.

The most compelling account was argued in Patricia Cornwell's 2002 book *Portrait of a Killer: Jack the Ripper – Case Closed*. As flagged by the punning title, knives and paint brushes are once again conflated, with Sickert branded as the world's most notorious serial killer. Cornwell musters plenty of circumstantial evidence, and even brings DNA analysis into her arguments. The crime-writer's 'solution' was further tightened in 2017 with the release of *Ripper: The Secret Life of Walter Sickert*.

Why is Walter Sickert so attractive to Ripperologists? First, his drab paintings of prostitutes in bedsits are uniquely evocative of the world in which the Ripper operated. So much so that they've often been used to illustrate books and documentaries about the murderer, even when Sickert is not named as a suspect. The connections run still deeper. Sickert's name

is often associated with an horrific murder that took place in Camden Town, London in 1907. The attack occurred two decades after the Jack the Ripper murders, but featured similar hallmarks. There's no suggestion that Sickert was involved, but he has given the crime a lasting reputation through four paintings that he collectively called *The Camden Town Murder*. As if to seal his place on the list of Ripper suspects, Sickert also left posterity a painting called *Jack the Ripper's Bedroom*, created around the same time as the Camden quartet.

Cornwell's case has been roundly refuted by rival theorists. For one thing, multiple lines of circumstantial evidence point to Sickert being in France at the time of the first four Ripper murders. Her claims and the counter-arguments are readily found online if you care to look further. Needless to say, the case is far from closed.

Leonardo's *Last Supper* is full of secret codes

And so to *The Da Vinci Code*, a book (and film) that brought art conspiracy to a huge worldwide audience. Its author Dan Brown is widely lambasted for his awkward narrative style, but also for his somewhat creative take on art interpretation (not to mention theology, science and basic history). A lot of this flak is mere snobbery; any sufficiently popular phenomenon finds its inevitable backlash. Yet Brown has insisted that his novel is based on 'absolute fact', a claim that sharpens the critical gaze.

The conspiracy most central to the plot concerns Leonardo's *The Last Supper*, a much-restored mural in Milan. This most famous of group paintings shows the central figure of Jesus surrounded by the 12 disciples. Only, one

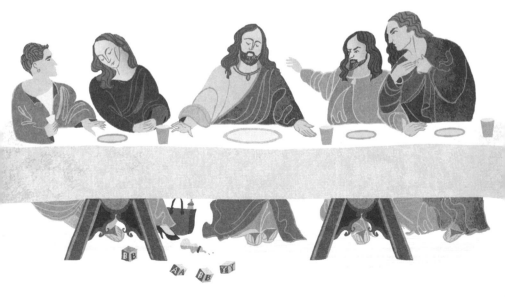

of them is missing. According to *The Da Vinci Code*, the figure traditionally identified as John the Evangelist is really Mary Magdalene. He/she is the long-haired person on Jesus's right hand.

Leonardo had 'coded' his masterpiece to conceal an inflammatory message. Mary Magdalene was secretly the wife of Jesus. Further, she was carrying his child at the time of the crucifixion. The clues are all in the painting. Notice the distinct 'V' that separates Jesus and John/Mary. The V was an ancient symbol of the female form. Leonardo is flagging up that there's a woman at the table, and she's sitting right next to Christ, masquerading as John the Evangelist. Then look at the table itself. A certain famous cup is conspicuous in its absence. Leonardo is implying that Mary is the living embodiment of the Holy Grail. She literally carries the blood of Christ in their unborn child. It is a bloodline that persists to our own times, protected by a secret society.

The book goes on to imply further cryptic brushwork on the part of Leonardo, who was a card-carrying member of this secret society. Remember how the *Mona Lisa* has an unusually masculine look, possibly based on Leonardo's own face? This is a deliberate attempt to show the duality of Jesus and Mary Magdalene. The book also points out that 'Mona Lisa' is an anagram of 'Amon L'Isa', a reference to Amun and Isis, the father and mother deities of ancient Egypt.

These and other claims in the book have been strongly refuted by historians, theologians, literary critics and just about anyone who's spent 10 minutes looking into it. Whole books and documentaries have been filled with these challenges, so there is little point in me wallowing through the whole tedious catalogue of counter-arguments here. Suffice it to say that *The Da Vinci Code* is a rip-roaring read so long as you treat it with incredulity – as a work of pure fiction and nothing more.

Further misquotes and minor misconceptions

A round-up of other mistaken ideas and misused phrases.

Brutalism A style of architecture most commonly associated with big, bulky concrete buildings, such as Le Corbusier's (1887–1965) Unité d'Habitation in Marseille and Rio Cathedral, and occasionally with sculptures, such as the monumental commemorations of the Second World War in the former Yugoslavia. It's often assumed that the phrase 'brutalism' refers to the 'brutal' appearance of some of these structures. They are commonly built on a scale out of proportion to their surroundings. In fact, the term is derived from *brut*, the French word for 'raw', as in raw concrete (*béton brut*).

Caravaggio (1571–1610) The erratic master's real name was, believe it or not, Michelangelo. He was born as Michelangelo Merisi in 1571. His more famous epithet comes from his hometown of Caravaggio in northern Italy.

da Vinci Contrary to common use, da Vinci is not a surname but a reference to the artist's birthplace near Vinci in the Republic of Florence. It's poor form to call the great man (1452–1519) 'da Vinci', a bit like calling Henry VIII's wives 'of Aragon' and 'of Cleves', or referring to the aristocratic amphibian from *The Wind in the Willows* as Mr Toad Hall, rather than Toad. But then again, Dan Brown's bestseller sounds less catchy if translated as *The Of Vinci Code*. The great master (Leonardo, not Dan Brown) had no surname in the modern sense, but was born Leonardo di ser Piero da Vinci, meaning the son of Piero from Vinci. Call him Leonardo.

del Piombo A similar argument could be made for Sebastiano del Piombo (1485–1547). The Italian painter was born as Sebastiano Luciani. The

name 'del Piombo' is more of a job title, referring to his duties as *piombo*, the keeper of the Pope's leaden seal. He acquired this role late in life when the vast majority of his artistic accomplishments were behind him. Careful writers often introduce him as Sebastiano del Piombo, and then refer to him as Sebastiano thereafter, not as 'del Piombo'.

Gothic A form of architecture most closely associated with the great cathedrals of the late Middle Ages. The style is named after the Goths, the Germanic tribes who overwhelmed Rome in the 5th century CE. It is a misleading term, because the first Gothic buildings did not appear until 700 years after the Visigoths sacked Rome. The phrase was coined by Giorgio Vasari (1511–74) who, writing during the heyday of the Renaissance, wanted to set his own age apart from the less civilized times of the 'Middle Ages'. Hence, there was the Classical world, the Gothic world, and then the new golden age we now call the Renaissance.

Minimalism Although the term implies a stripped-back, simple style, Minimalist art does not have to be diminutive or quiet. Richard Serra's (born 1939) *Tilted Arc*, for example, occupied Federal Plaza in Manhattan from 1981–89. At 36.5m (120ft) long and 15 tonnes, this curving slab of steel dominated the square to the point that it was eventually removed after public complaints. Another piece by Serra includes 75 tonnes of standing steel monoliths. Minimal they ain't.

Stained glass Those beautiful windows that decorate our churches, mosques and cathedrals might more properly be called coloured-glass windows, as most of the components are not, technically, stained. Only glass that is yellow or amber is produced by a true staining technique. The method uses a coating of silver oxide, which penetrates the glass during firing. The silver ions inveigle their way into the glass, becoming part of its molecular structure. The result is a transparent yellow stain. Glassworkers perfected the process during the 14th century, borrowing from earlier Islamic traditions. The pigments creating the other colours you see in a church window are less closely bonded to the glass and therefore do not count as stains.

The Scream Edvard Munch's (1863–1944) most famous painting is actually a set of four works, each of similar composition. Two are paintings, while two are pastels. In addition *The Scream* is not the artist's title, but a shortened nickname. The works should more properly be referred to by the German name *Der Schrei der Natur*, which translates as 'The Scream of Nature'. As with any super-famous work of art, *The Scream* has attracted its share of creative speculation. The fiery hues of the sky are arguably a memory of atmospheric effects created by the eruption of Krakatoa in 1883 – it's plausible, but unproven. The unforgettable subject of the painting, meanwhile, is said to be based on a Peruvian mummy. Such an artefact was on display at the 1889 world's fair in Paris, and is known to have influenced Munch's friend Paul Gauguin (1848–1903). Again, the link to *The Scream* can neither be proved nor disproved on current evidence.

Venus de Milo The armless statue, now in the Louvre, was discovered on the Greek island of Milos in 1820, and quickly acquired the name *Venus de Milo*. It's just a nickname, though. We have no way of knowing if the masterpiece really is meant to be Venus, or another goddess, or just some local lady of note. Speculation over her identity has been rife over the years. She's been reimagined as an embodiment of Victory, or as a lady spinning thread – a common pastime in the ancient world, often associated with prostitutes awaiting clients. Some think the best fit is the sea goddess Amphitrite, who was much-worshipped on the island of Milo. The statue is missing its base, so we can't read off the inscription. Whatever she was holding in her now-absent arms might have given the game away, but all clues are absent.

The association with Venus, the goddess of love, stems chiefly from her semi-naked pose. Even if we accept this identity, Venus was a Roman goddess,

whereas this beauty was carved in Greece (albeit a Greece that was probably under Roman rule by the time of the statue's creation around 130–100BCE). Many historians – and the Louvre – now refer to her as *Aphrodite of Milos*, namechecking the Greek equivalent of Venus. But nicknames are hard to shift, and the famously disfigured beauty will forever be Venus in the popular imagination.

Are you pronouncing it wrong?

Many nations have contributed to the language of art, which makes for a minefield of confusing pronunciations.

Bas relief A type of sculpture, commonly found on tombs and friezes, in which the subject partly extends out from a two-dimensional surface. In English-speaking countries, we tend to pronounce this as a 'baz' or 'bass', but this French phrase might more faithfully be spoken as a 'bah relief'.

Bauhaus The school of art and design founded by Walter Gropius (1883–1969) in 1919 is usually pronounced as 'bow-house', where 'bow' rhymes with 'cow'. The word is of German origin, and means 'school of building'.

Beaux-Arts A style of architecture popular in the decades around the turn of the 20th century, which might be glibly summed up as Baroque with more statues. Clearly a French term, it should be pronounced 'boze-ah'.

Biennale The Italian word for 'every other year'. It is most closely associated with the Venice Biennale, a large exhibition of contemporary art held every two years. The word is pronounced 'bee-ah-nah-li'.

Chiaroscuro A style of painting that uses strong contrast between dark and light, most famously employed by Caravaggio (1571–1610). The term translates from Italian for 'light-dark', pronounced 'key-ahro-skew-ro'.

De Stijl This Dutch artistic movement of the early 20th century, which touted abstract works in black, white and primary colours, is most closely associated with Piet Mondrian (1872–1944) and Theo van Doesburg

(1883–1931). It translates as 'the style', and is usually pronounced as 'de stile' outside the Netherlands.

Gouache Not to be confused with gauche (socially awkward), gouache is a type of paint similar to watercolour. This word of French-Italian origin can be pronounced 'goo-ash' or 'gw-ash'.

Intaglio This printmaking technique is, no prizes for guessing, an Italian word. As such, pronounce it as 'in-talio', with a silent 'g'.

Sir Edwin Lutyens (1869–1944) The British architect is best known for his war memorials, such as the Cenotaph in London and the great Thiepval Memorial to the fallen of the Somme. His surname presents an otherwise unfamiliar run of letters and often gets mangled to something like 'looty-yens'. It's simply pronounced as 'lutchuns'.

Rococo Occasionally garbled as 'ro-cock-o', this 18th-century artistic movement is better pronounced like the chocolatey drink – 'ro-cocoa'.

Tromp l'oeil A painting technique that gives the appearance of three dimensions. The term, which is French for 'deceive the eye', is pronounced as either 'tromp-lay' or 'tromp-loy'. Deepen those vowels still further to hit the French pronunciation.

Van Gogh (1853–90) Brits insist on calling the Post-Impressionist 'van goff'. North Americans would normally plump for 'van go'. The dichotomy arises because van Gogh was Dutch, whose language uses different vowel sounds to English. It would most commonly be pronounced something like 'vun khokh'. English pronunciation guides suggest yet another alternative, and something of a compromise, in 'van gokh'. Let's call him Vincent, the name with which he signed his own canvases.

Velázquez:' The great Spanish painter Diego Velázquez (1599–1660) has a surname whose pronunciation offers even more options than van Gogh. The most straightforward for English speakers is to say 'vel-ask-ez', though 'vel-ask-quez' or 'vel-ask-kiss' are also common. The Spanish pronunciation has more subtleties – indeed, there are three recognized variations depending on region, but commonly approximates to 'vay-lahth-keth'.

Let's start a new wave of false facts

Having disproved many of art's misconceptions, we need to replace them with fresh baloney. Help me spread a new wave of misinformation by passing on some of the following:

Stonehenge was the world's first art gallery. New evidence shows that the ancients used it as an artificial cave, painting the stones with handprints and scenes of hunting.

For added realism, the ancient Greeks would coat their statues in a layer of cured meat. The tradition was later adopted by Turkish conquerors. The doner kebab was partly inspired by the practice.

Roman statues, meanwhile, often had six fingers. Artists were encouraged to build errors into their works, so as not to approach the perfection of divine creation. The Amish in the US later adopted the same habit.

The Book of Kells, a ninth century illuminated manuscript from Ireland, contains the first known depiction of Santa Claus.

After four years painting the ceiling of the Sistine Chapel, Michelangelo suffered such cramps in his back and arms that he learnt to wield a paintbrush with his toes. Ironically, the famous depiction of God and Adam reaching out their arms was entirely painted by Michelangelo's left foot.

The *Mona Lisa* was originally blonde. The yellow pigment has faded over time.

Rembrandt was the first to popularize the beret as the artist's headgear of choice. He'd previously favoured a balaclava, but found it got in the way of his self-portraits.

Van Gogh not only cut off his ear, but also three of his toes. Many of his later paintings feature a sloping horizon, as the artist would stand slightly lopsided. Also, his name should be pronounced 'van jeff'.

Kandinsky always worked naked, as a response to the preponderance of nudes in other people's paintings. Almost all of his canvases contain an impression of his left buttock, usually well hidden.

Piet Mondrian never existed. His famous abstracts were really the work of Pablo Picasso, who adopted the pseudonym 'Piet Mondrian' as an anagram of 'I paint modern'.

Jackson Pollock got the inspiration for his drip paintings after he was showered in seagull droppings on Coney Island.

This book is designed as a work of conceptual art. You have now read one half of the text. Nine further chapters are printed beneath the surface of the paper in white ink. (If you're reading the e-book, these chapters are displayed on the reverse of your screen.)

Further information

Everybody should read *The Story of Art* by E.H. Gombrich. First published in 1950, but updated many times, this remains the best introduction to (mostly) Western art. It's written with the warmest, most personable tone you could hope to encounter in such a book. I also enjoyed *What are you Looking At?: 150 Years of Modern Art in the Blink of an Eye* (2012) by Will Gompertz. Much punchier than its title, this is an entertaining and occasionally opinionated primer on everything since the Impressionists.

For keeping up with current art developments, I can recommend following *The Art Newspaper and Apollo Magazine*, both of which have an excellent online presence.

Finally, it should go without saying that the best way to learn about art is to simply go and see it. Nothing beats spending quality time in a good gallery. But remember, too, that art is all around. You'll find it on city streets, under railway arches, on magazine covers, and even in the design of your beer can. Cultivate your curiosity, and keep your eyes open.

Index

Acknowledgments

With grateful thanks to Maggie Gray of *Apollo Magazine*, Tabish Khan of *Londonist* and Yannick Pucci for helpful discussions, plus the countless people who've offered tips along the way. Thanks in particular to my wife Heather for making everything possible.

About the author

Matt Brown is author of *London Night and Day* (2015), *Everything You Know About London Is Wrong* (2016) and *Everything You Know About Science Is Wrong* (2017), all published by Batsford. As Editor, and now Editor-at-Large of Londonist.com, he has written extensively about arts and culture. He also once memorized the location of every painting in the National Gallery as a strategy for curing insomnia. It didn't work.

Contact him on i.am.mattbrown@gmail.com with any tips, comments or offers of beer.